Growing Up in New York

From the Library of:

Daniel Thau Teitelbaum, M.D.

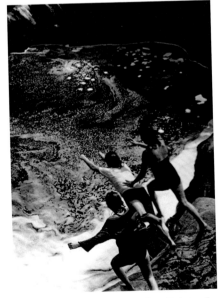

Physician, Rabbi, Photographer, Printmaker
Hamilton College, Class of 1956

Growing Up in New York

Photographs by ARTHUR LEIPZIG

with a Foreword by Gordon Parks

 An Imago Mundi Book

David R. Godine, Publisher

BOSTON

This is an Imago Mundi Book,

first published in 1995 by

David R. Godine, Publisher, Inc.

Box 9103

Lincoln, Massachusetts 01773

Copyright © 1995 by Arthur Leipzig

Foreword copyright © 1995 by Gordon Parks

All rights reserved. No part of this book may be used
or reproduced in any manner whatsoever without writ-
ten permission, except in the case of brief quotations
embodied in critical articles and reviews.

Printed by the Stinehour Press

Designed by Jerry Kelly

LIBRARY OF CONGRESS
CATALOGING-IN-PUBLICATION DATA

Leipzig, Arthur, 1918–

Growing up in New York: photographs / by Arthur
Leipzig ; preface by Gordon Parks

p. cm. — (Imago mundi series)

1. New York (N.Y.) — Social life and customs —
Pictorial works.

2. Documentary photography — New York (N.Y.)

I. Title. II. Series: Imago mundi book.

F128.37.L53 1995

974.7'1'00222 — dc20 95-35327

CIP

ISBN 1-56792-051-9

A special thanks to my wife, Mimi, whose insightful ideas and cogent criticism have contributed so much to my photography. Her skills as a professional researcher and writer as well as her feedback continue to be an important part of my life's work.

Thanks to my daughter, Judith, for her helpful editing of my writing and thanks to my son, Joel, for his expert technical assistance. Thanks also to Howard Greenberg, George Adams, and Connie Wirtz for their contributions to the *Growing Up in New York* project, and to Jerry Kelly for his superb book design.

A.L.

Foreword

Arthur Leipzig has caught the smell of New York, its hustle and bustle, along with the uptown and downtown humanity that colors this towering city's blood. Unhurriedly his eyes have moved endlessly through its heat and cold, watched its rivers run beneath proud bridges and lingered in roaring subways that snake beneath its surface. Shifting from course to course his images keep you remembering places, moments and events you have seen; fill you with regret for not having seen some things you did not see.

Photographic reportage can be a strange alchemy. Pictures born of a confident photographer's heart become his personal language, an effigy it seems of the subject-matter he chooses. Leipzig opens up our feelings to so many things, immeasurable things that have given license to his unbridled eye. His curiosity appears inexhaustible and keeps sprouting – breaking through the darkness of impoverished moments in a Harlem ghetto to slyly grow into the absurdity of some tyrannical lady who graced the roster of the bigoted Daughters of the American Revolution. It would be difficult to rub out the memory of boys diving into the East River – enough to make one want to be a boy forever; children lost in their enjoyable street games; two small children in the window of a Chinese laundry; a tousled-haired naked child folded into deep sleep – while nearby and dangerously high, men work the spidery webs of Brooklyn Bridge.The boxers, the famous musicians who have long since gone to their graves; the bejeweled ladies and starch-shirted men preening before the camera during opening night at the opera. The sight of all these leave nostalgic memories swimming in your head.

Having seen so much it seems that Arthur Leipzig wanted to go on seeing much more, and what he has shown us remains hauntingly clear. His images say, look at us and be born again. Taken out of time they refuse to grow faded, and with the clock moving on, Arthur Leipzig's camera should be moving with it. He should never yield to inactivity. Life as he shows it is what life is all about.

Gordon Parks

Growing Up in New York

I came to photography quite by accident. I had no idea what I wanted to be when I was growing up, in a middle-class family living in a middle-class section of Brooklyn. I used to go to the library to read about occupations. I started with the A's – Agriculture, Archaeology, Architecture – but never made it as far as the P's. When I was 17, I left school and worked at an assortment of jobs – truck driver, salesman, office manager, assembly line worker. Finally, I worked in a wholesale glass plant, where I seriously injured my right hand and lost the use of it for fourteen months. I began to search for a new way to make a living. A friend suggested that if I studied photography at the Photo League, I might be able to get a job as a darkroom technician. I registered for a beginning class at the League. Two weeks later I knew that photography would be my life's work.

My life as a photographer began in the streets of the city. For me, New York, with its diverse cultures and varied topography, presented a new challenge every day. My days were spent shooting with my 9 x 12cm Zeiss Ikon camera; my nights in the darkroom and in discussion with other students and photographers. I was obsessed. It was in New York that I honed my skills and began to learn about the world and about myself.

In 1943, while working on *The Newspaper PM*, I shot my first major photo essay, "Children's Games." The streets were an extension of the home. They were the living rooms and the playgrounds, particularly for the poor whose crowded tenements left little room for play. The children occupied the streets, now and then allowing a car or truck to pass.

Over the years, I have worked as staff and freelance photographer for a wide variety of publications. My assignments and my independent projects took me all over and under the city, always searching for the human face of New York. I photographed

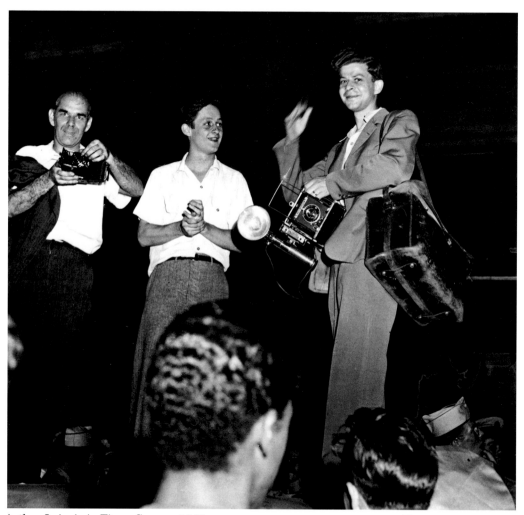

Arthur Leipzig in Times Square, 1945

Photo by Simon Nathan

people on the subways and on the beach in Coney Island, painters working on the Brooklyn Bridge, kids swimming in the East River; I photographed the night life and the violence, the working class and the upper class. In those days I traveled all around the city at any time of night or day, and except for rare instances I seldom felt in danger. The city was my home. As I look back at the work that I did during that period I realize that I was witness to a time that no longer exists, a more innocent time.

While I know that the city has changed, that the streets are dirtier and meaner, the energy that I love is still there. No matter where I go, I keep coming back to photograph New York. Of course the "good old days" were not all sweetness and light. There was poverty, racism, corruption, and violence in those days, too, but somehow we believed in the possible. We believed in hope.

Arthur Leipzig

Most of the photos in this book were taken on assignment for magazines and newspapers, or as part of independent projects. A few of the photos, such as *Sleeping Child*, were simply wonderful moments that suddenly presented themselves, demanding to be captured.

Growing Up in New York

Children's Games

In 1942, television and video games did not exist. In working-class neighborhoods there was little room for playing at home, so kids played out in the streets. They played games that had been handed down for generations, as well as others they made up. If one kid had a ball, someone else found a bat – a broomstick or a piece of wood. Boys played rough games like King of the Hill and Johnny on the Pony. Girls played Hopscotch (which in Brooklyn was called Potsy). Most children were left to their own resources.

One day I discovered a print of a wonderful painting by Peter Brueghel the Elder called *Children's Games* (1560). I was struck by how similar games played nearly four hundred years earlier in Flanders were to the ones being played outside our window. So began my journey through the city streets to do my photo essay on children's games.

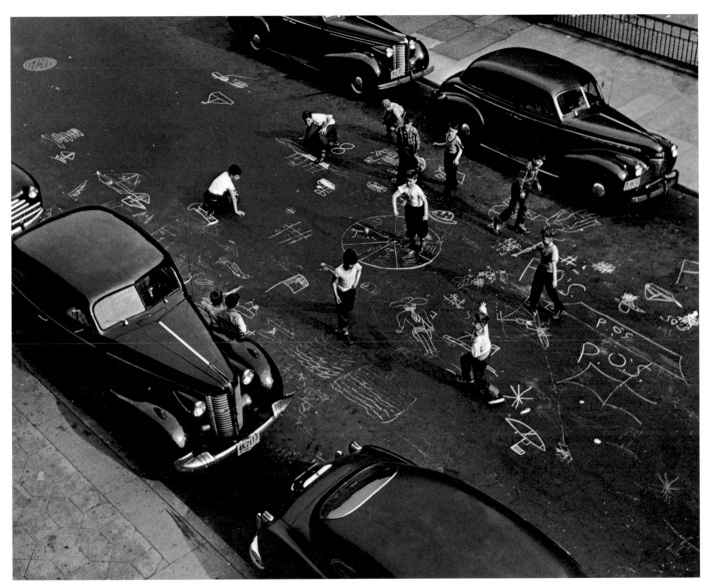

Chalk Games, 1950

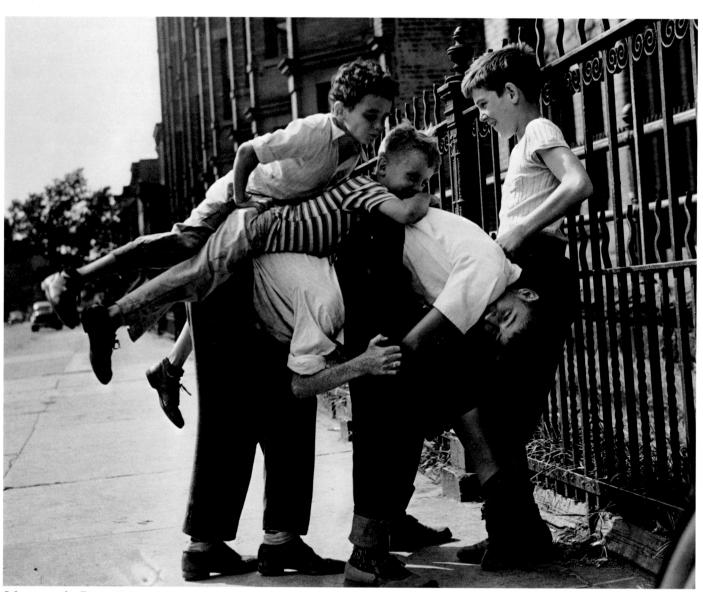

Johnny on the Pony, 1943

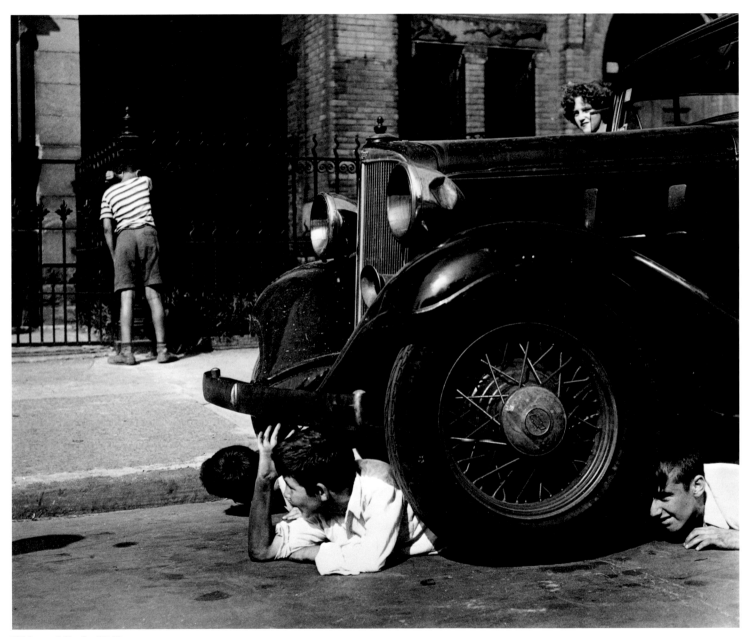

Hide and Seek, 1943

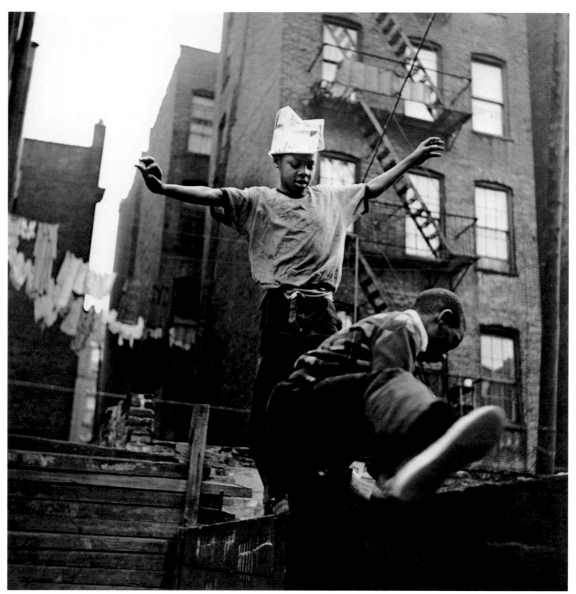

Fence Walk, 1951

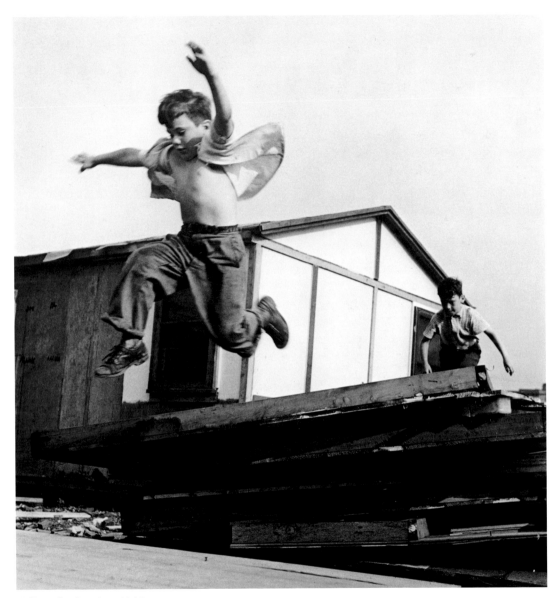

Follow the Leader, 1943

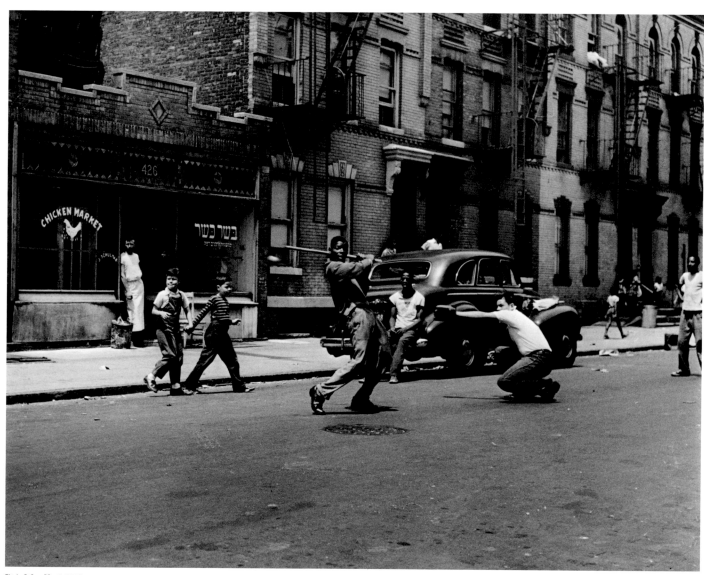

Stickball, 1950

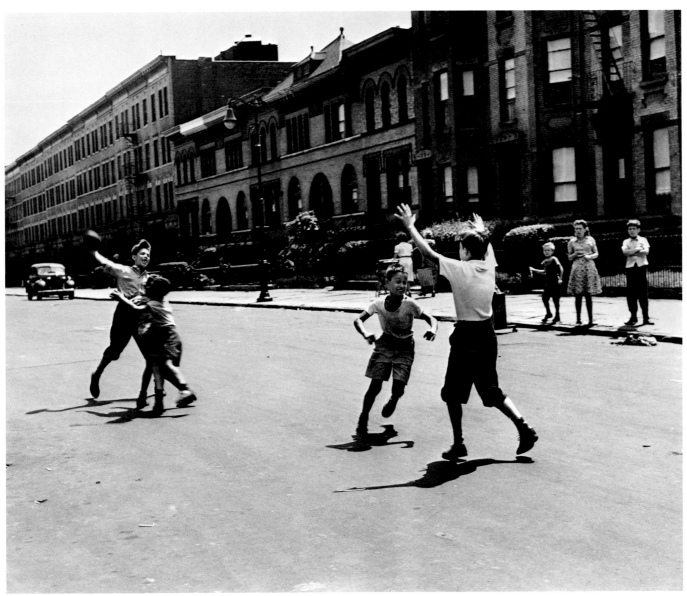

Association Football, 1943

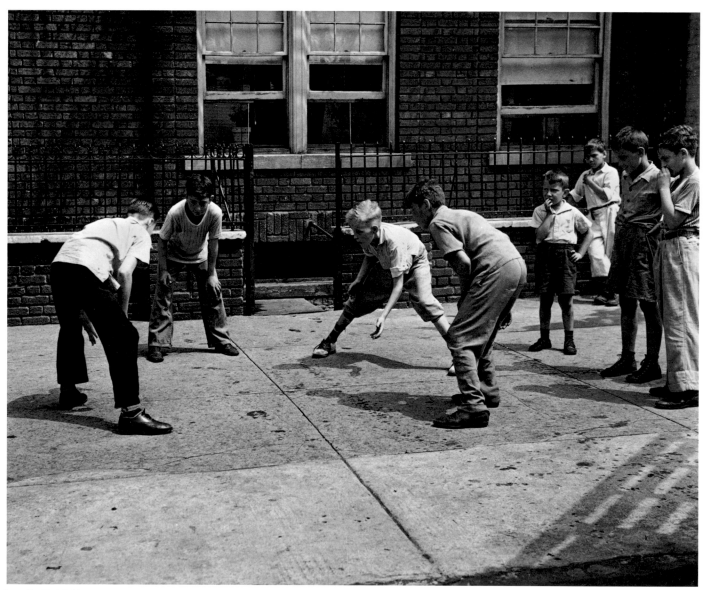

Box Ball, 1944

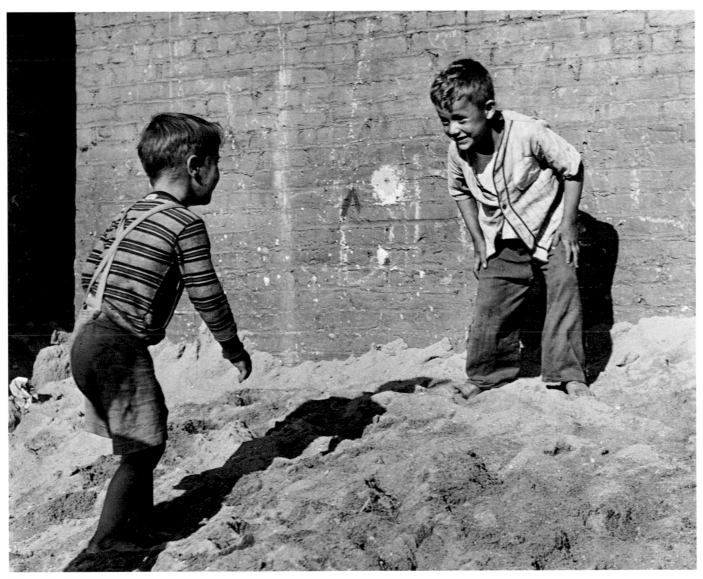

King of the Hill, 1943

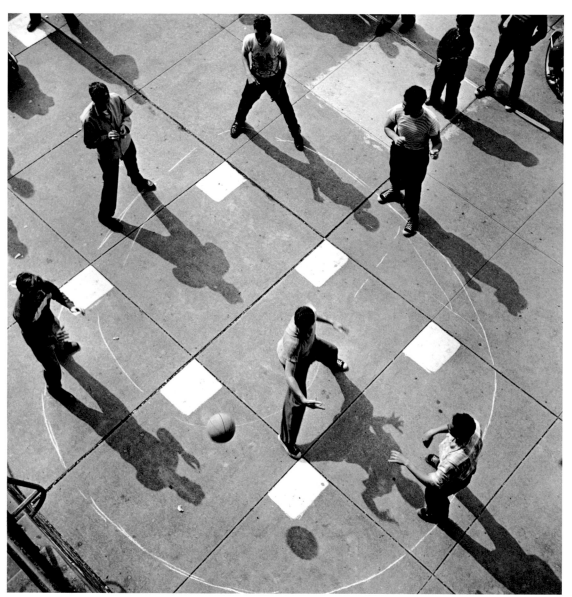

Dodge Ball, 1950

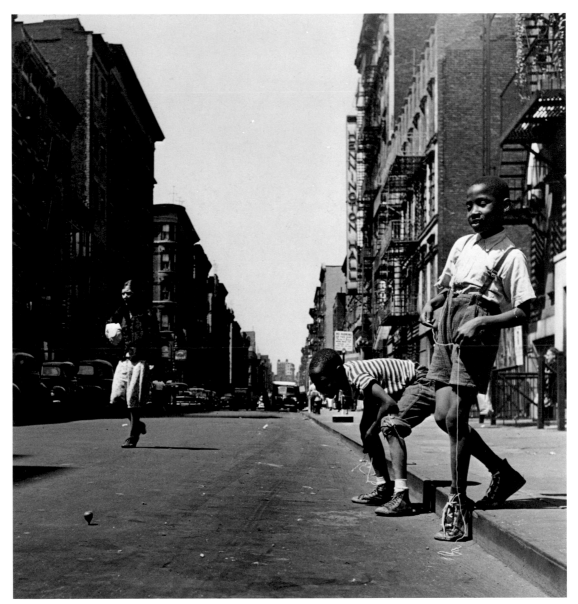

Tops, 1950

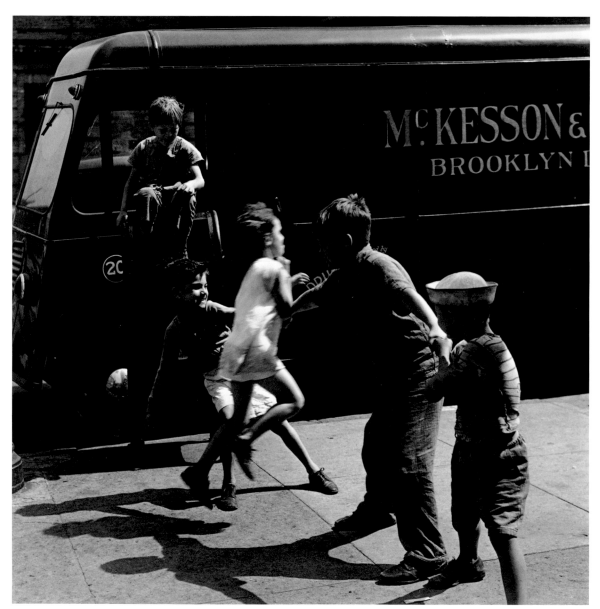

Rover Red Rover, 1943

War Games

The boys in these photographs were hard at play the afternoon I approached their vacant lot on Dean Street in Brooklyn. They were completely engaged in their war games, using their imagination to turn simple objects into elements of the world they fantasized: a blade of grass pressed to a rock became a grenade; the empty lot was the battlefield. I wanted to photograph them, but before I could begin the kids saw my camera and the war stopped. They all lined up for a group photo. When I told them I would take their picture only if they were playing, they returned to their game, and within moments were immersed in the war. It was their absorption and their lack of self-consciousness that made these photographs possible.

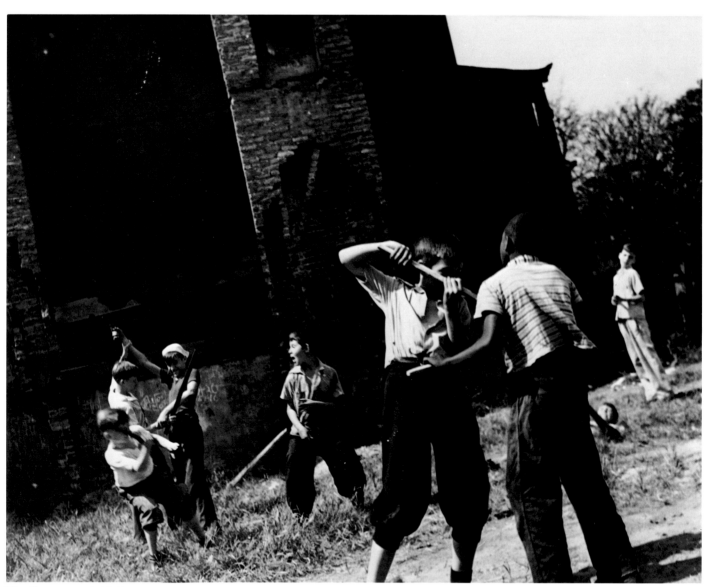

War Games no. 1, 1943

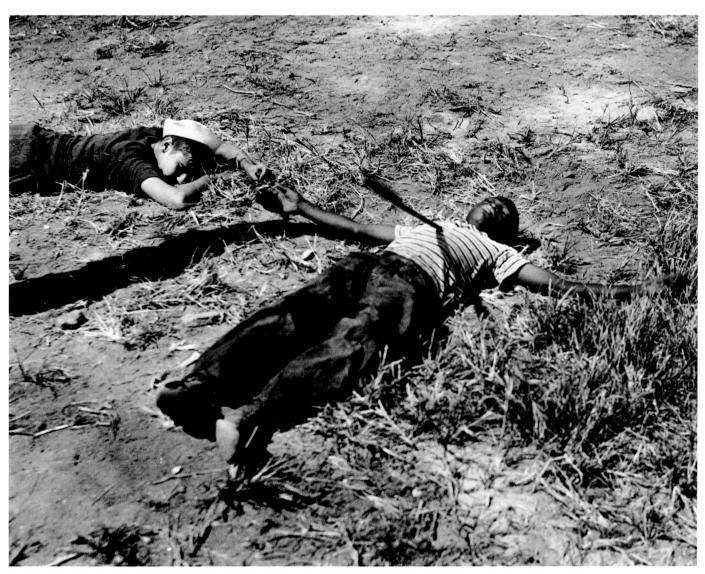

War Games no. 2, 1943

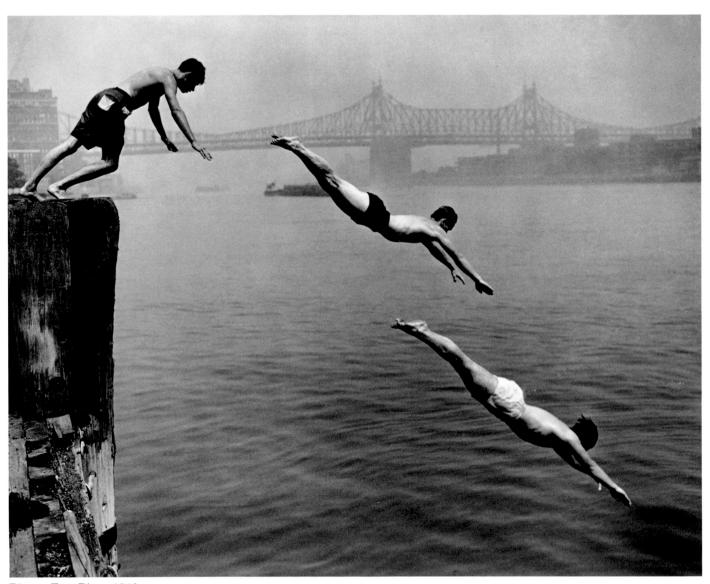

Divers, East River, 1948

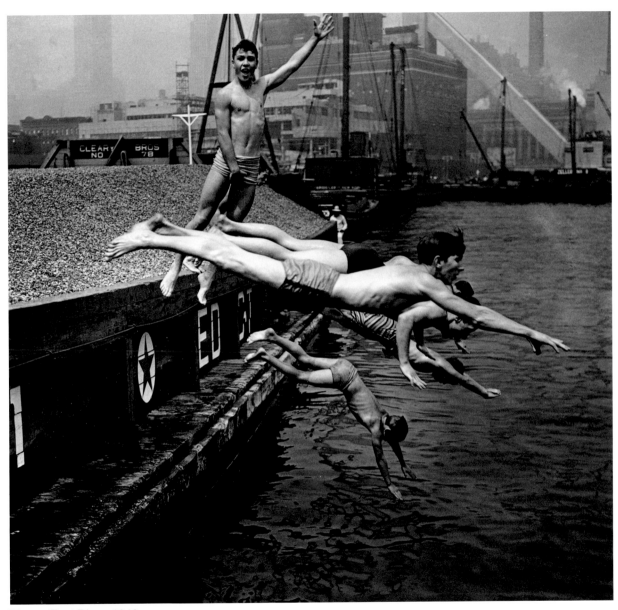

Divers, East River, 1948

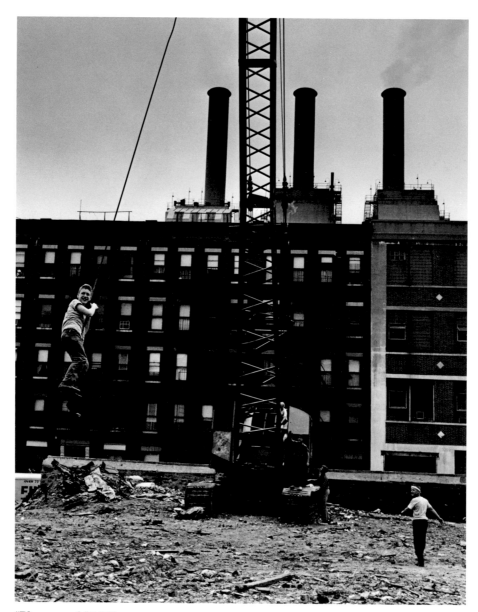

"Playground," 1962

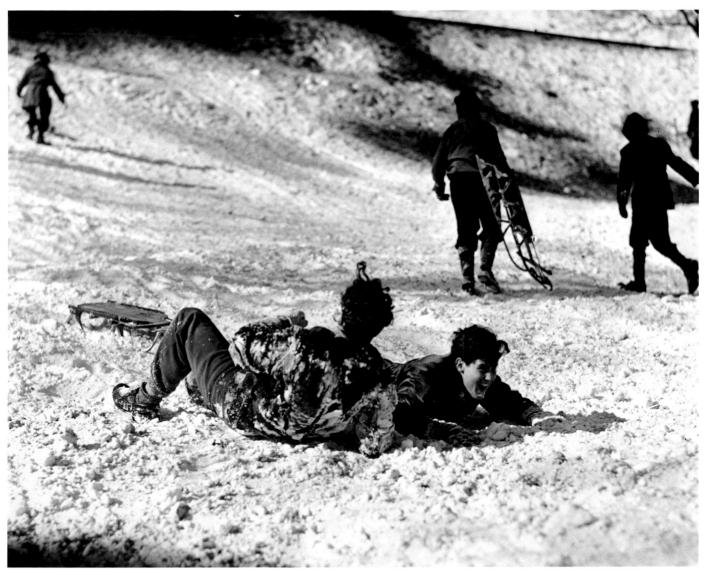

Prospect Park, 1945

Subway

When I was growing up, the subways were everyone's primary means of transportation. They were cheap (a ride cost only a nickel), fast, safe, and even clean. As I rode from Coney Island to Manhattan to the Bronx, I spent a lot of time watching the other riders. Once the train doors closed, people seemed to sink into their own private worlds, and it was easy to see their concerns played out on their faces. I was eager to take photographs, but worried that my camera would be an intrusion.

It took me six months to devise a technique that would let me photograph in the subways without destroying the atmosphere. I built a "dog carrying" box to house my Rolleiflex camera. The box had four holes – two for the camera lenses, and two to make the box appear more authentic. There was an opening on the top for viewing and a door that I could open to focus and transport the film. A long cable release attached to the camera came up underneath the handle. The box worked beautifully. I rode the subways, photographing day and night for three months – the only difficulty I encountered being the occasional animal lover who wanted to see my "dog."

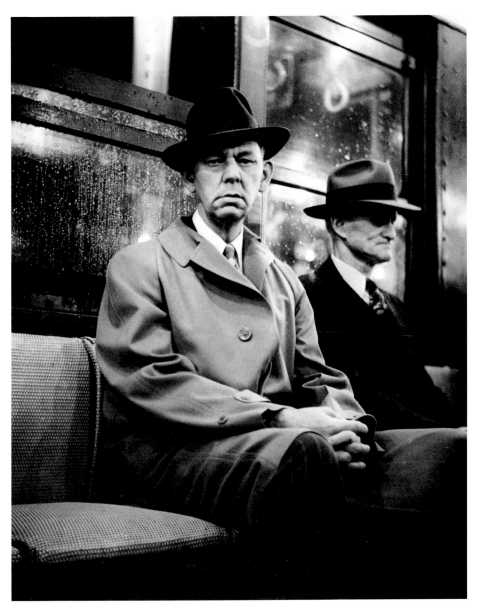

Subway (Wall Street), 1949

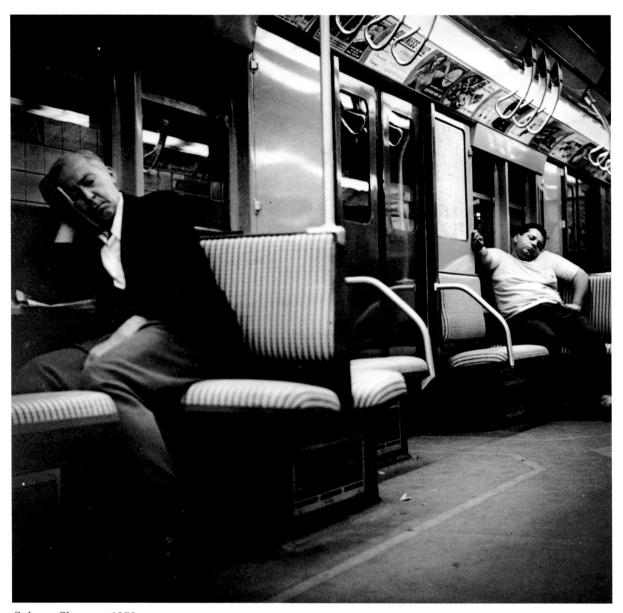

Subway Sleepers, 1950

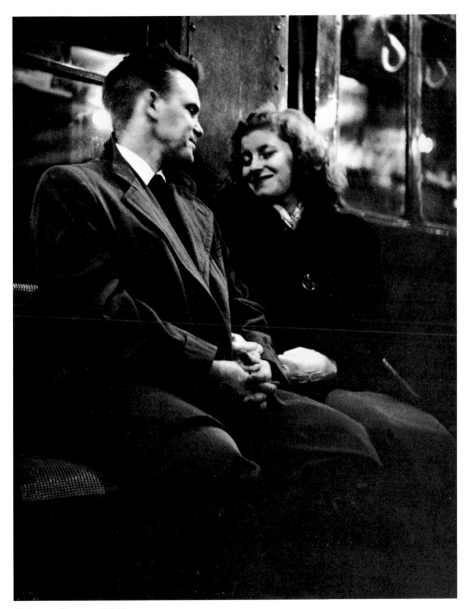

Subway Lovers, 1949

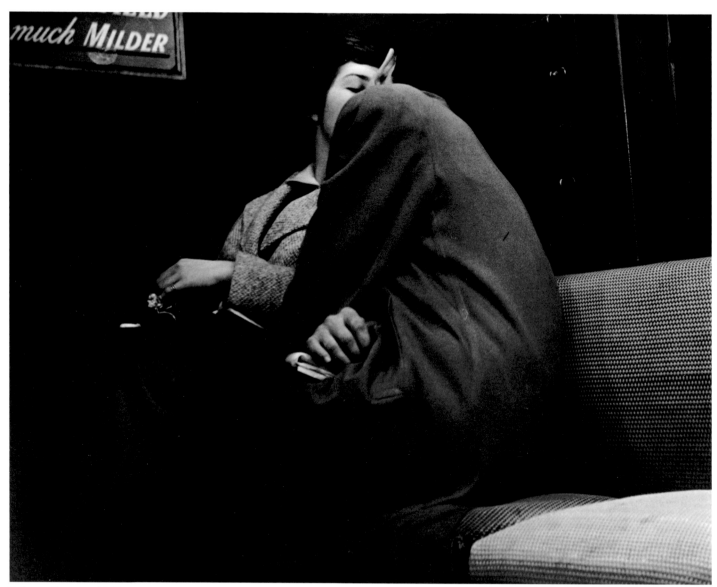

Subway Lovers, 1949

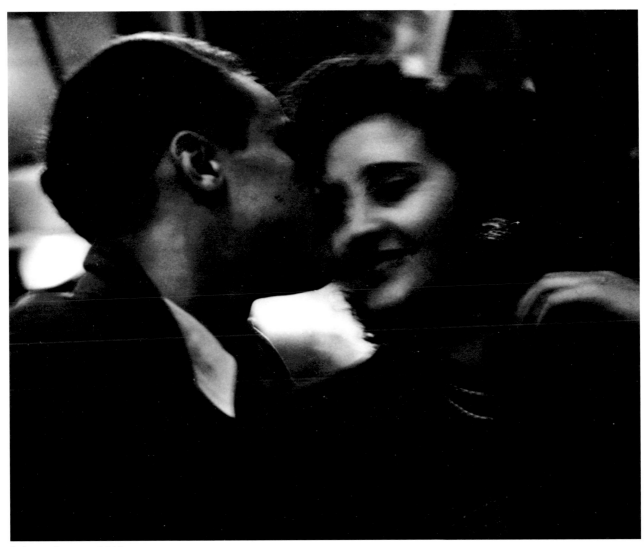

Subway Lovers, 1949

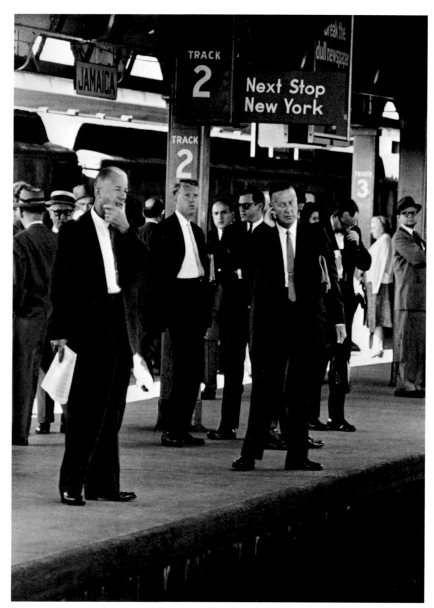

Commuters, 1962

Assignment Brooklyn Bridge

International News Photos had given me an assignment to photograph the painters painting the Brooklyn Bridge. I arrived at 7:30 in the morning, feeling very anxious. I met the painting foreman, who instructed me on how to climb the bridge. "The first thing you have to know when you climb a bridge," he said, "is *never* look down." Of course I couldn't stop myself from staring at the road bed below me. I followed the foreman as he walked up the cable. I held on to the guy wires, my camera bag over my shoulder, my Rollei around my neck. The foreman walked ahead of me, completely at ease. As we climbed higher and higher, I noticed that the bridge was swaying and so were the guy wires. Now and then I stopped, ostensibly to take a photo, but really it was because I was just plain scared. My eyes were fixed on the cars speeding across the bridge. I knew that with one misstep I would plunge to my death.

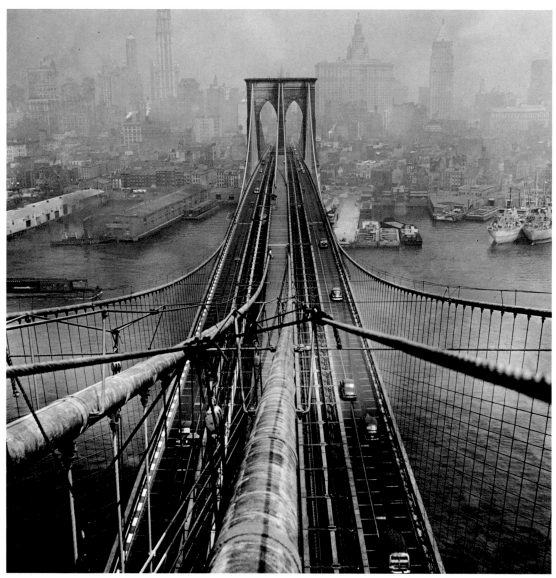

Brooklyn Bridge, 1946

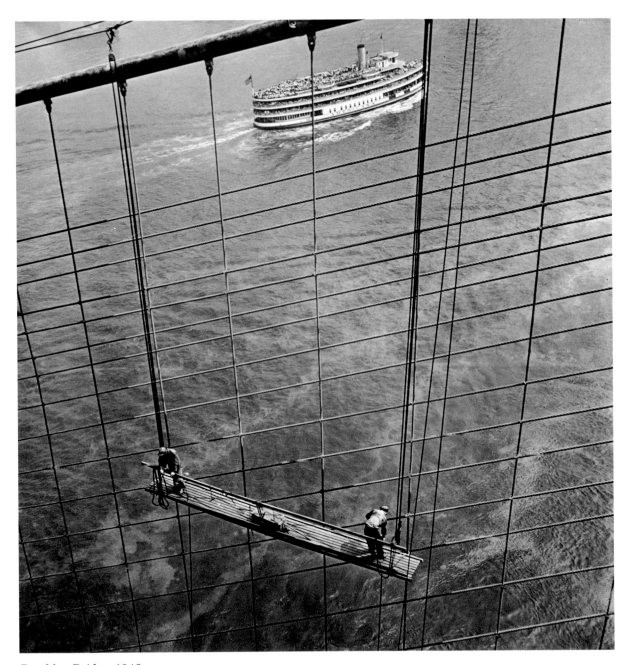

Brooklyn Bridge, 1946

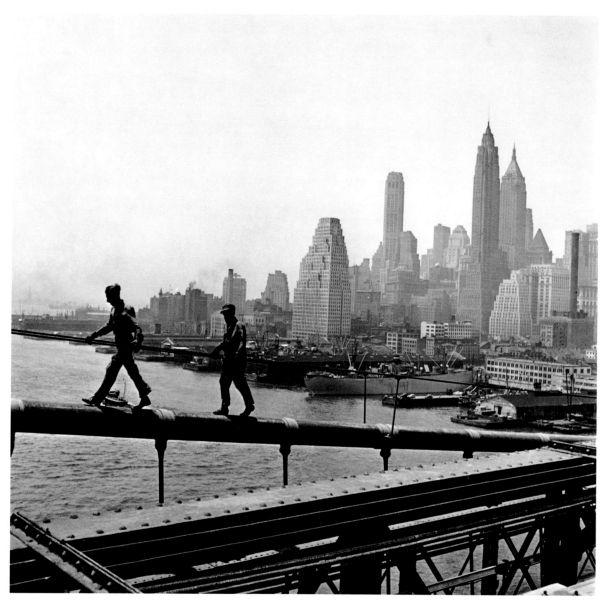

Brooklyn Bridge, 1946

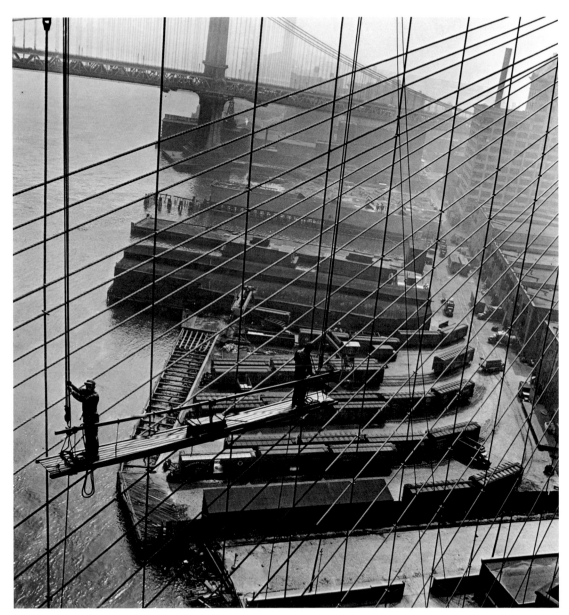

Brooklyn Bridge, 1946

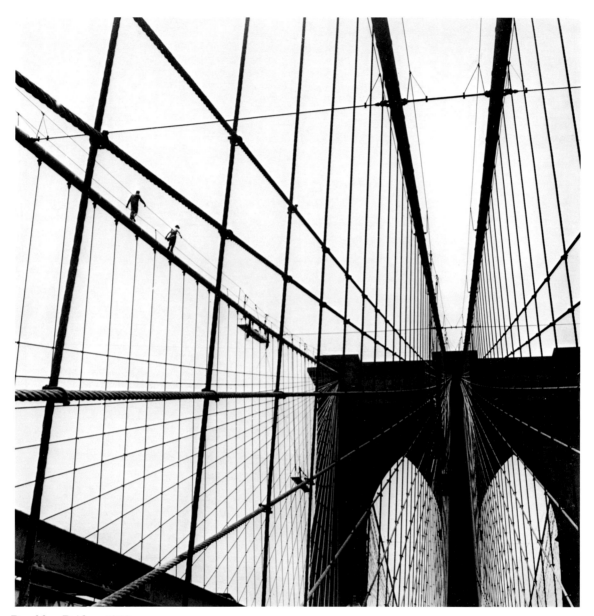

Brooklyn Bridge, 1946

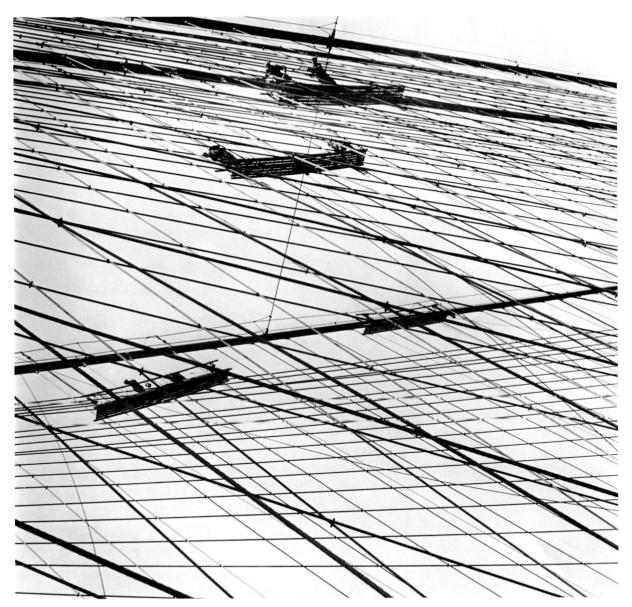

Brooklyn Bridge, 1946

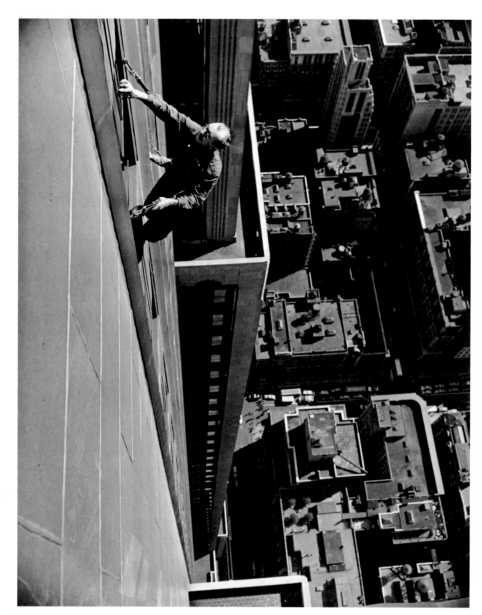

Window Washer, Empire State Building, 1948

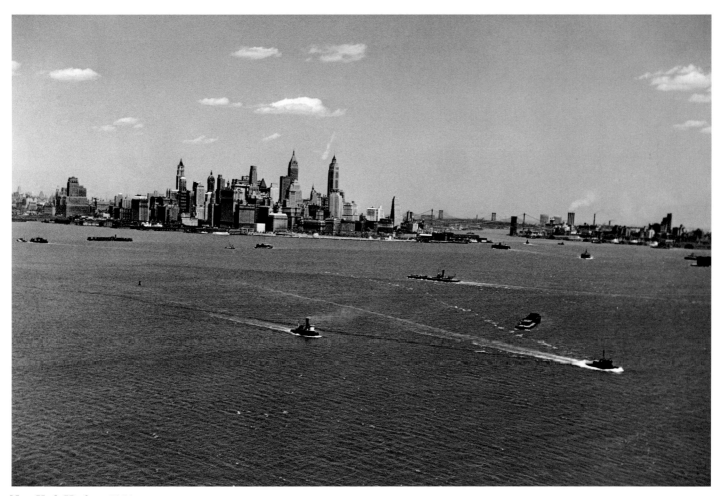

New York Harbor, 1951

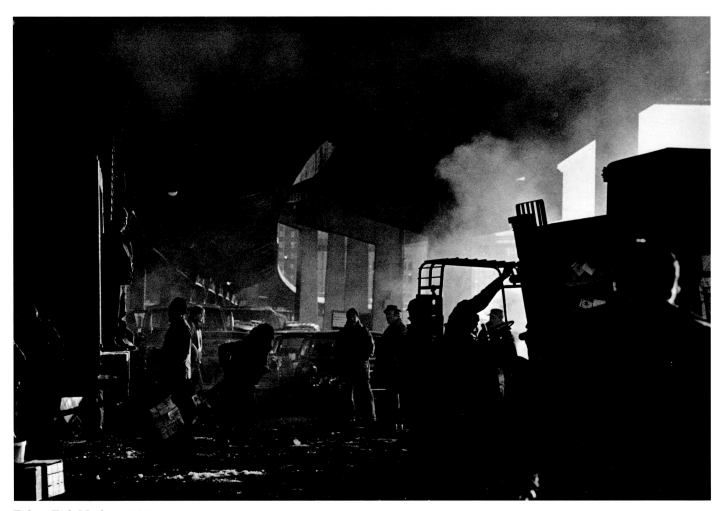

Fulton Fish Market, 1969

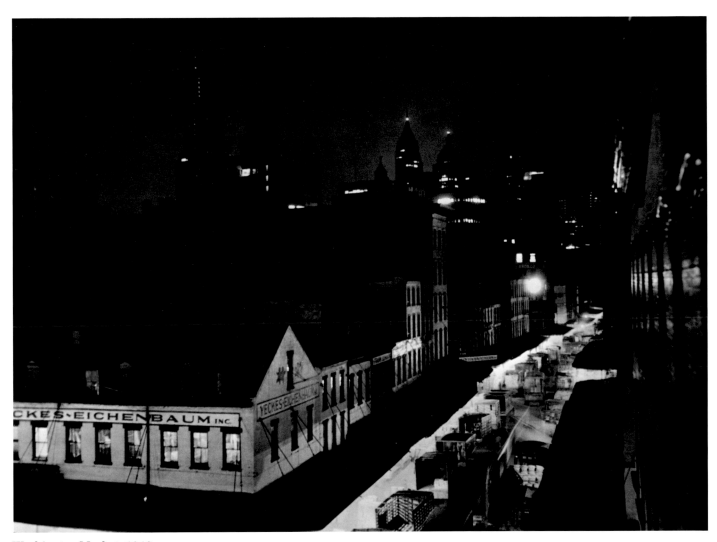

Washington Market, 1946

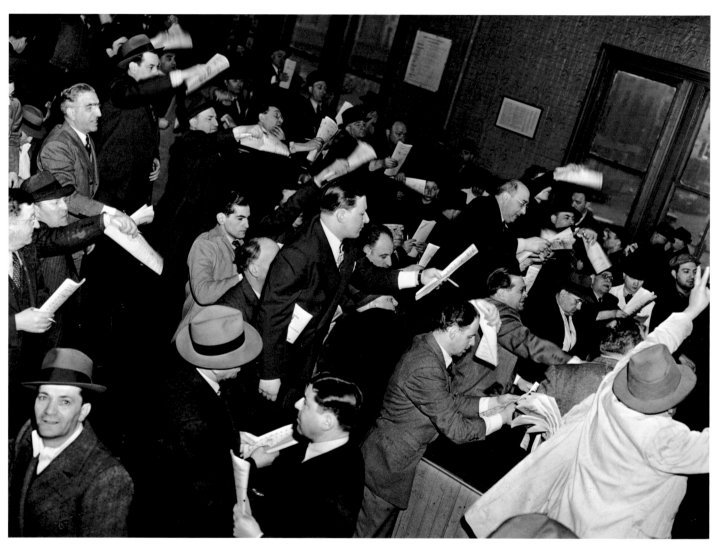

Butter and Eggs Exchange, 1946

Garbage

The idea of photographing garbage came to me from my friend Marty Solow, who in 1967 suggested I do an essay on garbage in New York City. It was an intriguing idea, and with his help I arranged to follow the trail of garbage wherever it went. For weeks I rode the garbage trucks and scows and went out to the dumps. I thought, smelled, and photographed garbage. The resulting photo essay was published in *New York Magazine*.

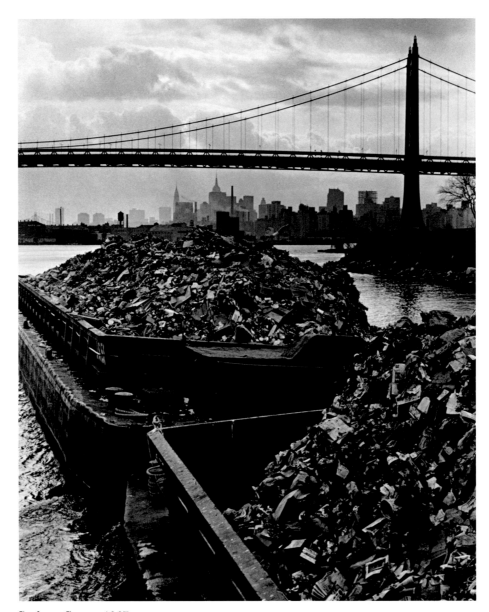

Garbage Scows, 1967

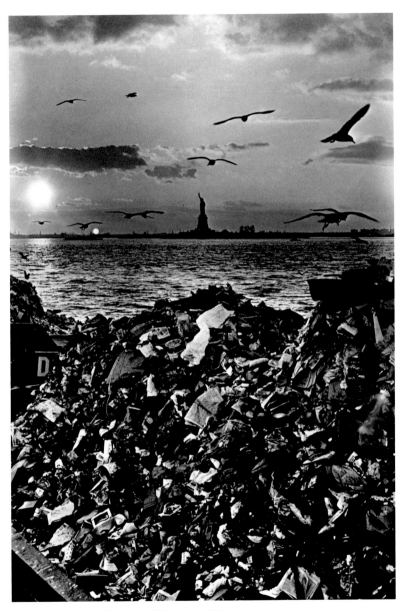

Garbage and the Statue of Liberty, 1967

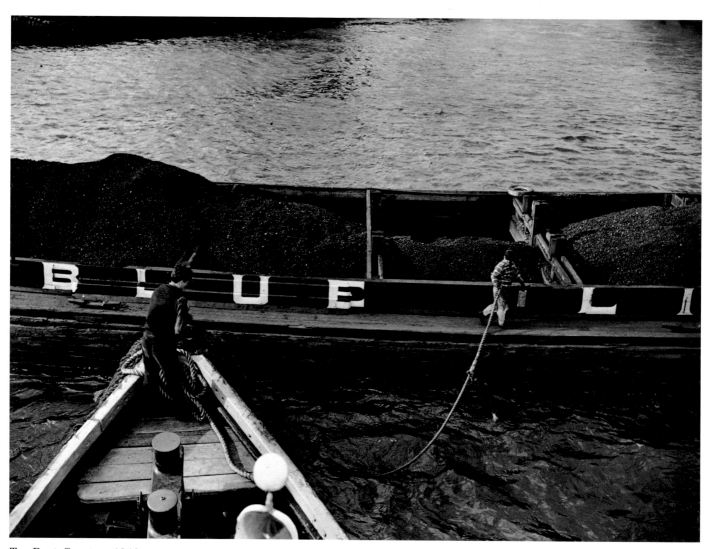

Tug Boat, Spartan, 1946

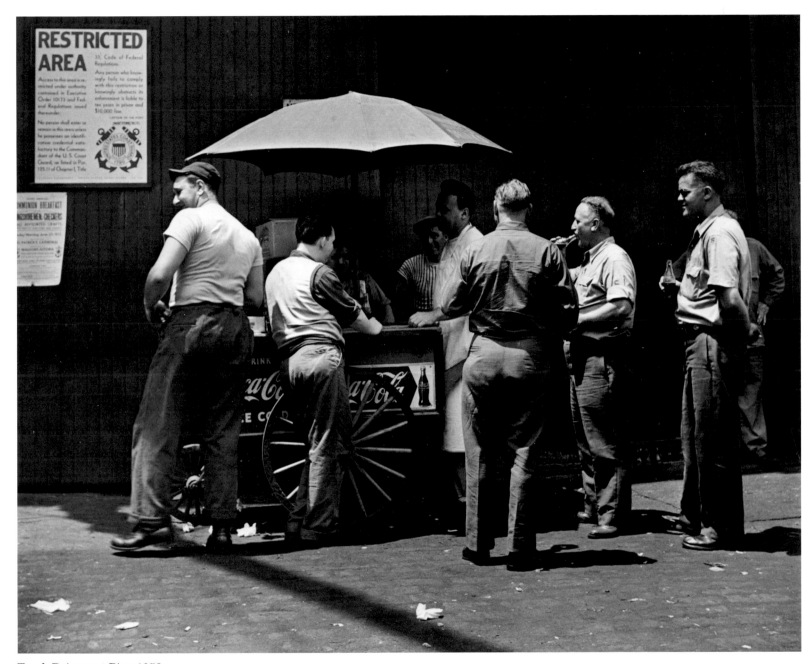

Truck Drivers at Pier, 1952

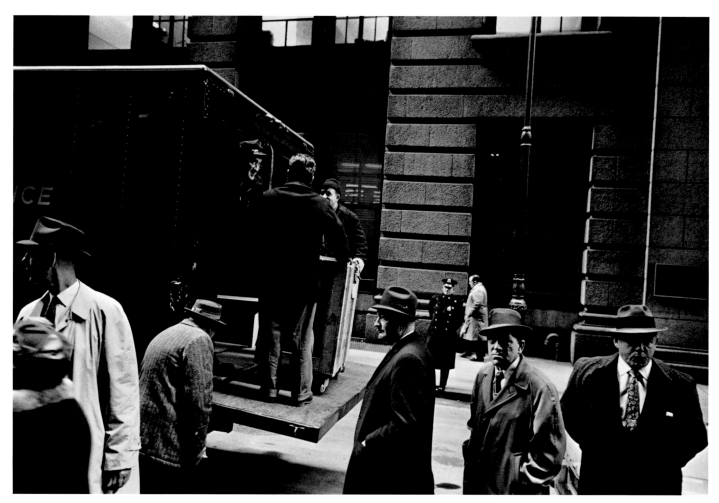

The Big Move, Chase Manhattan Bank, 1961

The Big Move, Chase Manhattan Bank, 1961

Sanitation Worker, 1967

Coney Island

In the 40s and 50s, people came to Coney Island from all over the city, no matter if they lived in ghettos or in the genteel middle-class neighborhoods. They came to escape the heat, the crowded city, and their everyday lives. As they left the train at Stillwell Avenue, they entered another world, where their cares fell away. It was a day to swim, to lie on the sand, to gorge oneself on Nathan's hot dogs and thrill to the rides. Everyone got badly sunburned, but even though they'd be unable to sleep that night, it was all worth it. As soon as they could they'd come back again.

In 1950, I had an assignment to photograph the roller coaster riders. I wanted to capture the terror and excitement on the people's faces. With my Speed Graphic in hand, I lay face down across the top of the front two seats, facing the other riders. A burly roustabout sat on my back to hold me down. The cars began to move and I started taking pictures. When we reached the top of a steep incline and started down the other side, the roller coaster picked up speed. I struggled to hold my camera steady. There was a turn and a dip and the roustabout lost his hold and flew off my back. I was terrified both for him and for me. I wanted to help, but my position was too precarious to let go. Fortunately, he managed to grab the edge of the car with one hand and, after hanging outside it for a few agonizing seconds, he pulled himself back in and onto my back.

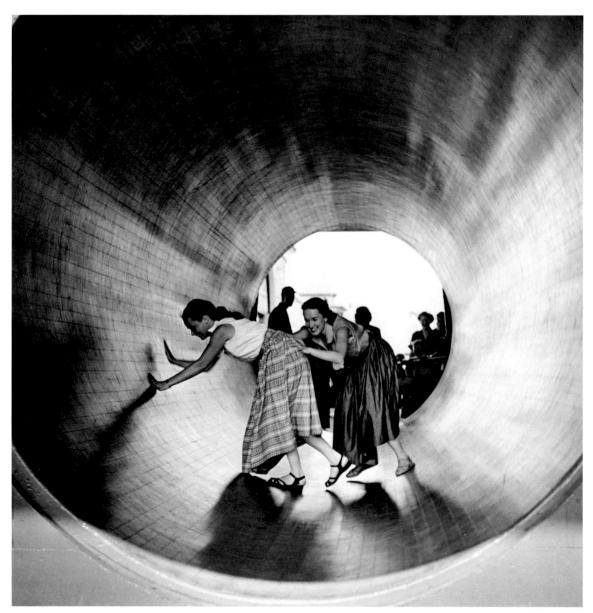

Turning Barrel, Coney Island, 1952

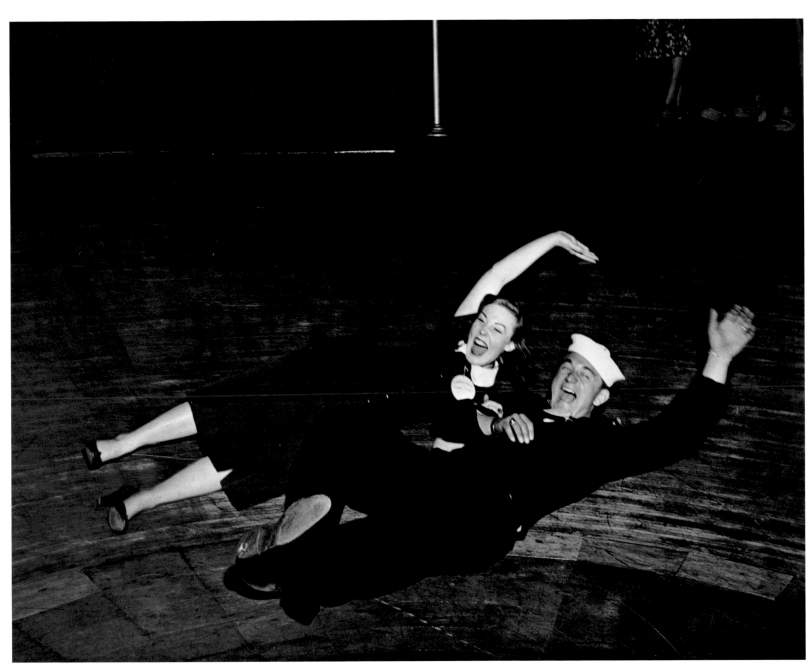

Steeplechase, Coney Island, 1949

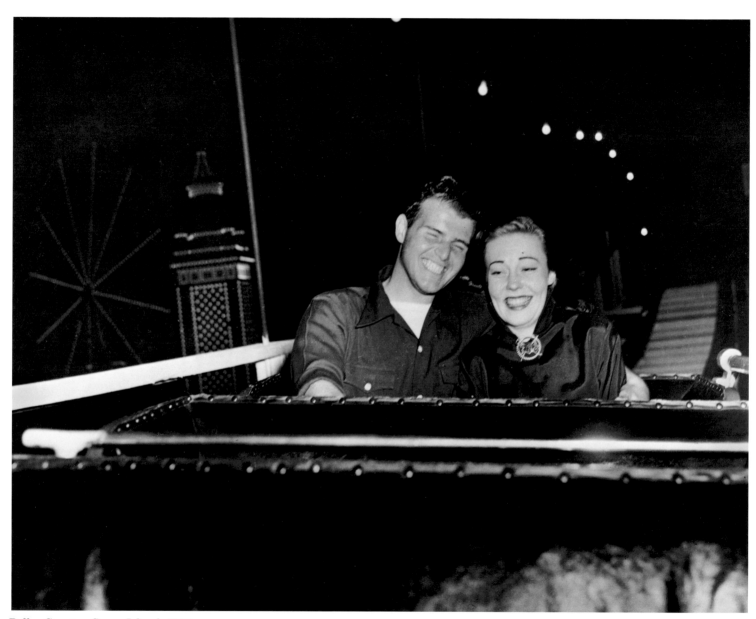

Roller Coaster, Coney Island, 1950

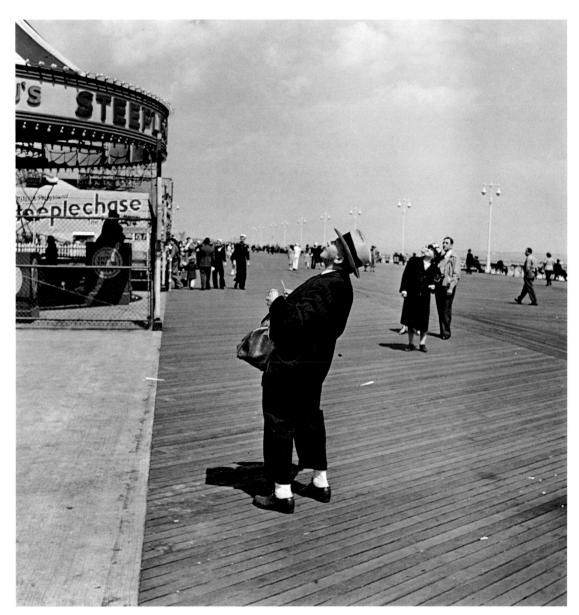

Boardwalk, Coney Island, 1952

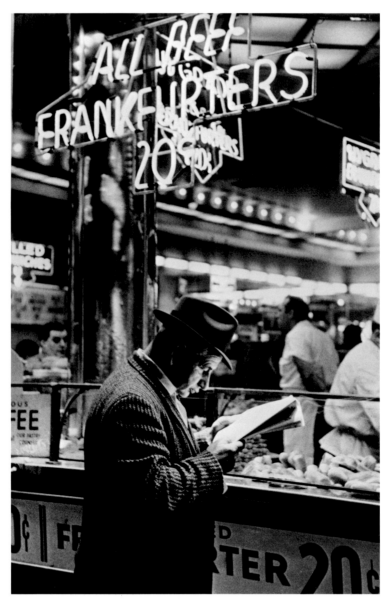

Nathan's, Coney Island, 1967

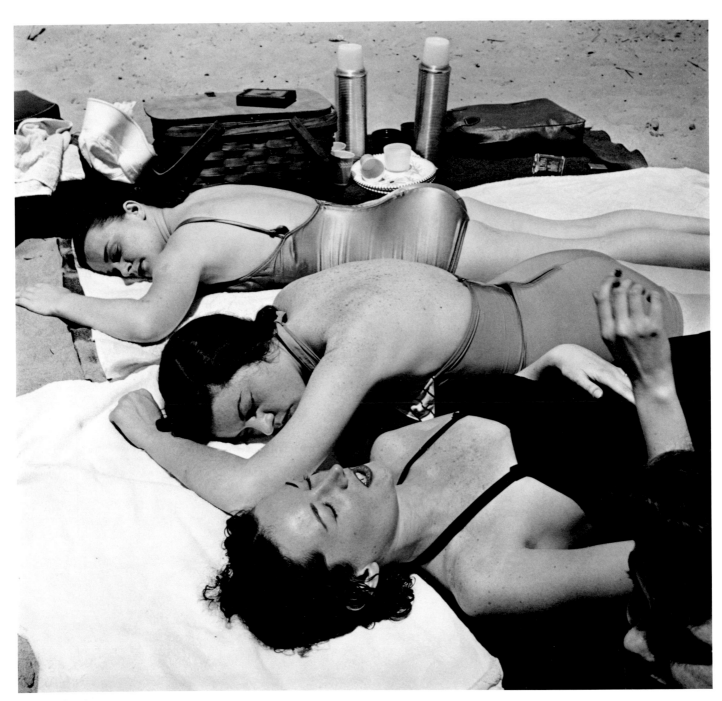

Coney Island, 1952

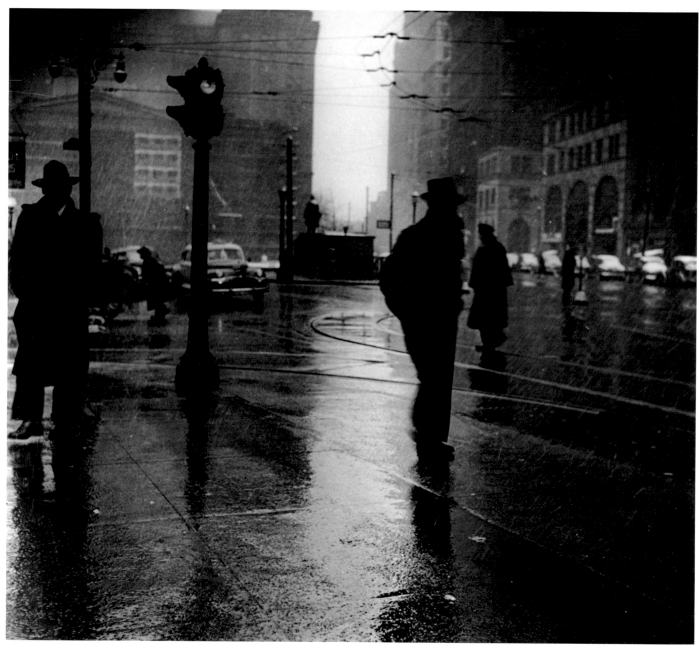

Rain, 1945

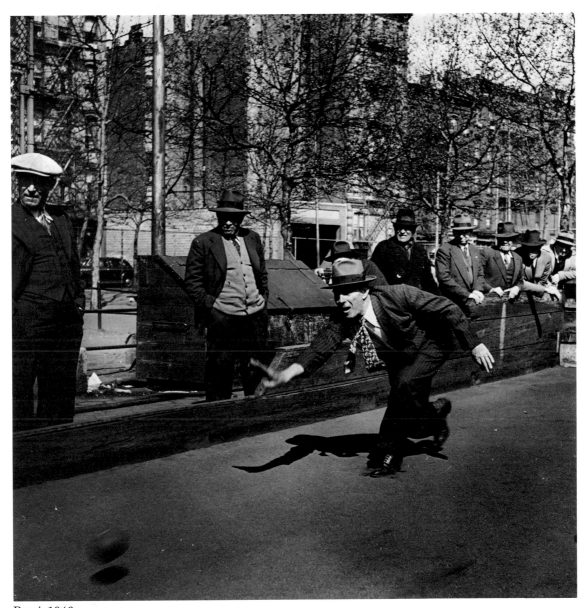

Bocci, 1946

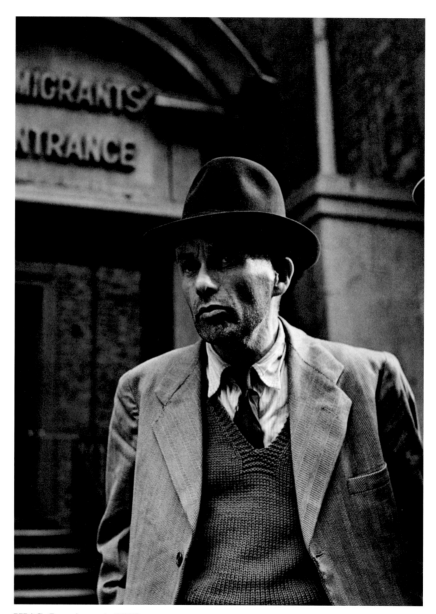

HIAS, Immigrant, 1950

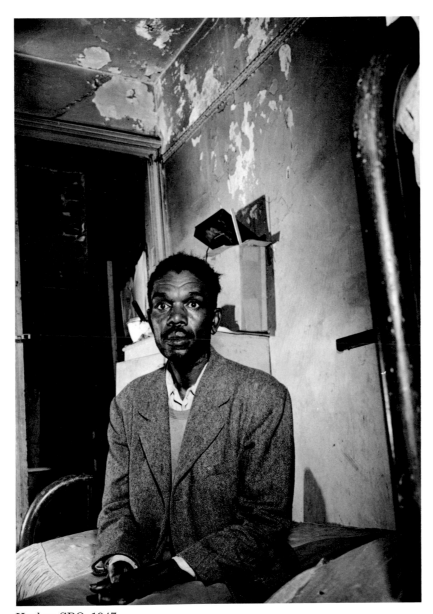

Harlem SRO, 1947

Strike at the Daily News

In July 1945, all the city newspapers except *The Newspaper PM* were on strike. I was assigned by *PM* to cover the action at the *Daily News*. *The News* had a history of violent strikes, and this one was no exception. Every night when the papers came off the presses, gangs of strikebreakers prepared to cart off the copies while strikers tried to stop them. The police rode their horses into the crowds and swung their billy clubs with fervor. Photographers in the midst of all this had to watch out for everybody: the police, the strike breakers, and the strikers.

One night in late July, I was walking along 41st Street at the rear of the *Daily News* building when word came that there had been a stabbing on 42nd. I raced around the corner ahead of the other photographers in time to see a crowd of strikers restraining a fellow striker whose brother had just been stabbed. I jumped up onto the roof of a car and immediately took a picture of the scene. Suddenly, all the rage of the strikers was focused on me. I became the symbol of the enemy. Usually, explaining that I worked for *PM* would have been good enough, since *PM* was viewed as sympathetic to the strikers' cause. But on this night, reason wasn't working. The strikers surrounded the car and started to come for me. I took another photo and jumped off the car, still protesting that I was from *PM*. As I stood there, I knew that there was nothing I could do to get through to the angry men surrounding me. I waited for the inevitable. Suddenly a group of *PM* news drivers on the picket line recognized me. They charged through the crowd yelling over and over: "He's all right, he's from *PM*!" All but a few of the strikers backed off, and the *PM* drivers formed a protective wall around me until everyone calmed down.

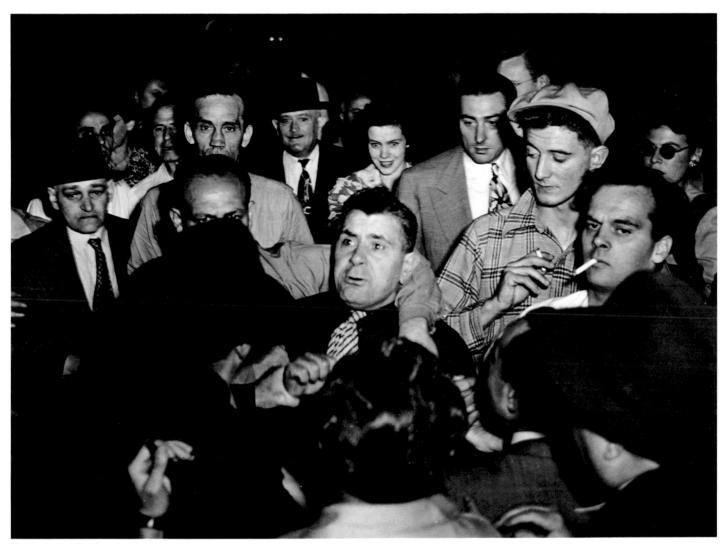

Daily News Strike, 1945

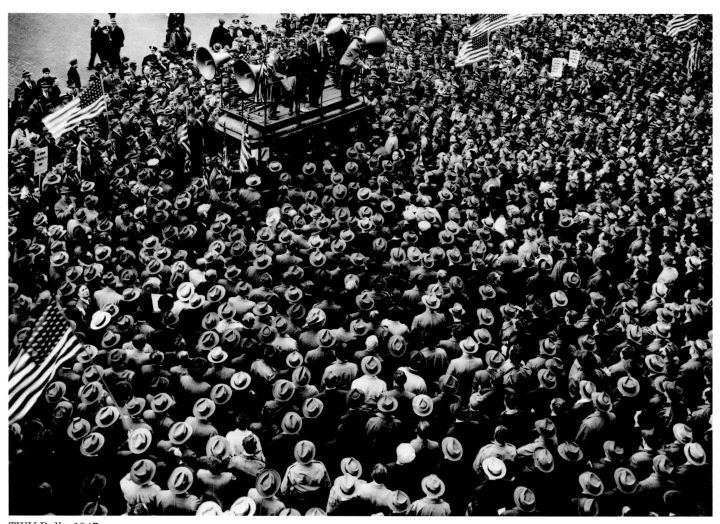

TWU Rally, 1947

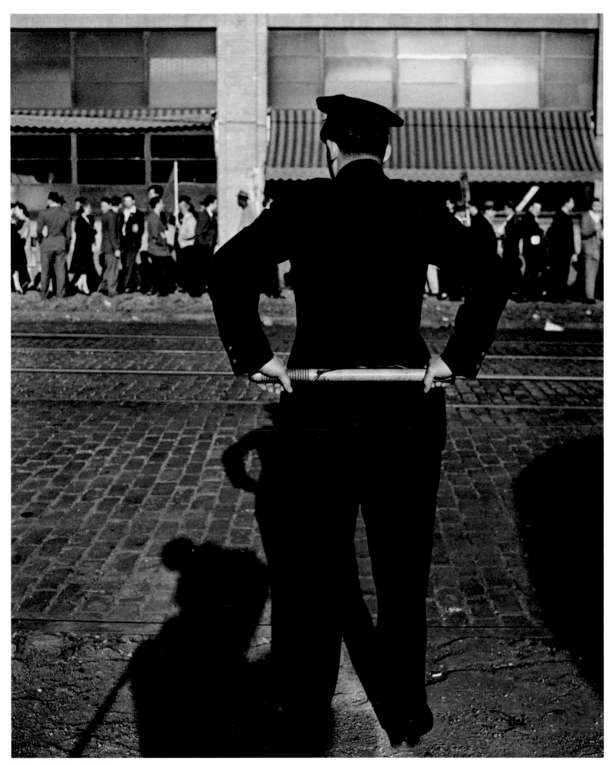

Sit-in Strike, 1948

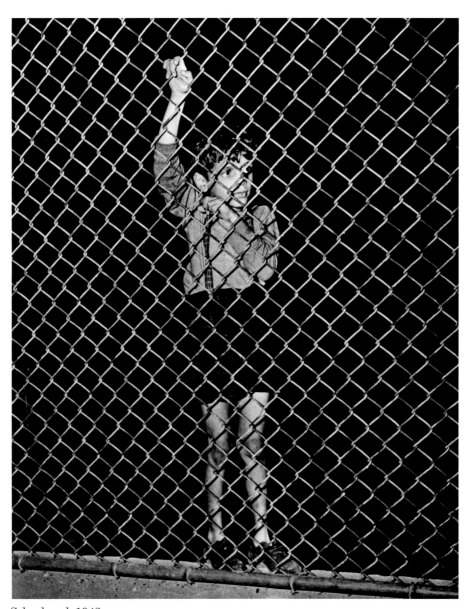

Schoolyard, 1943

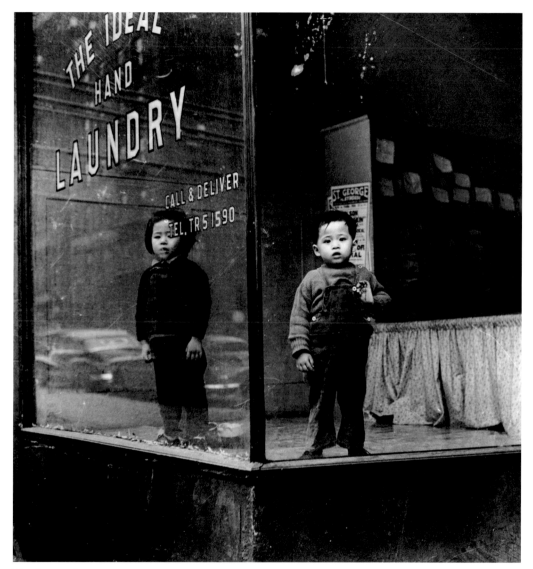

Ideal Laundry, 1946

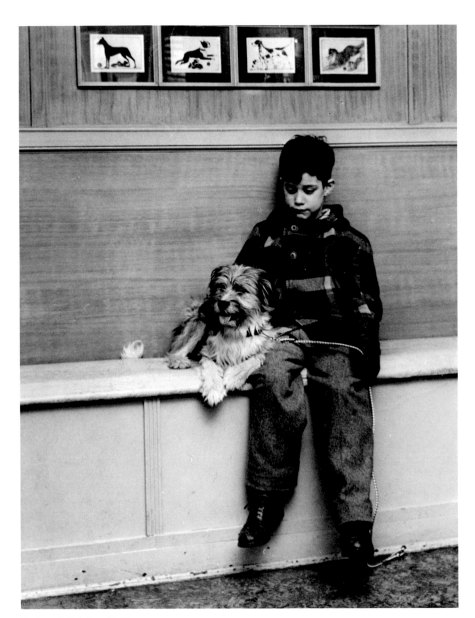

Joel and Frisky, 1952

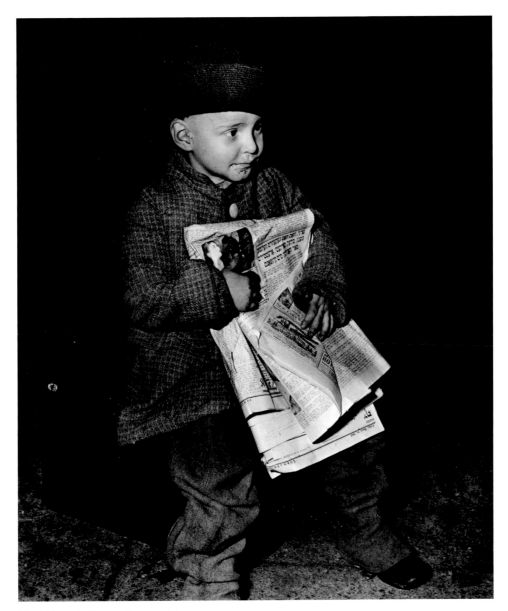

World War II Waste Paper Drive, 1944

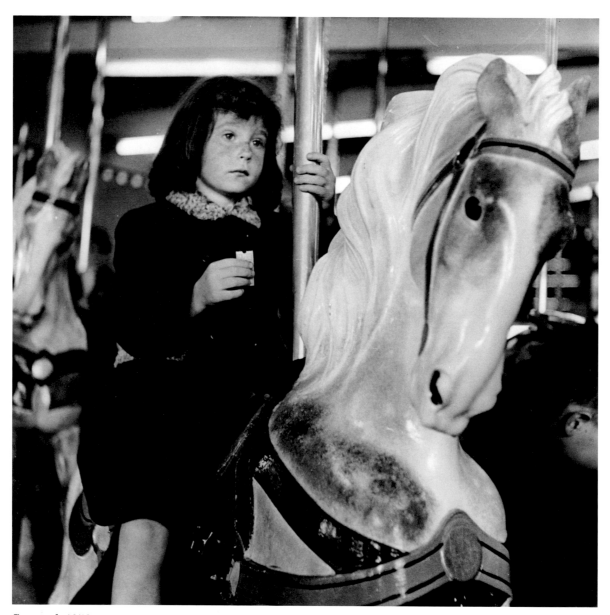

Carousel, 1956

Watching Santa

PM sent me to photograph a mechanical Santa Claus sitting surrounded by toys and dolls in the window of Namm's department store in Brooklyn. The oversized Santa was the first of its kind. I climbed into the window carrying a heavy 4 x 5 Graflex with a ten-inch lens. At first, I tried to take my pictures hiding behind the Santa, but I soon realized that it wasn't necessary: he was far more interesting than I was. As his belly shook and his head moved from side to side, calling out, "Merry Christmas! Ho! Ho! Ho!," crowds of holiday shoppers stood transfixed with their faces pressed against the glass – while I, standing in full view, took all the photos I needed.

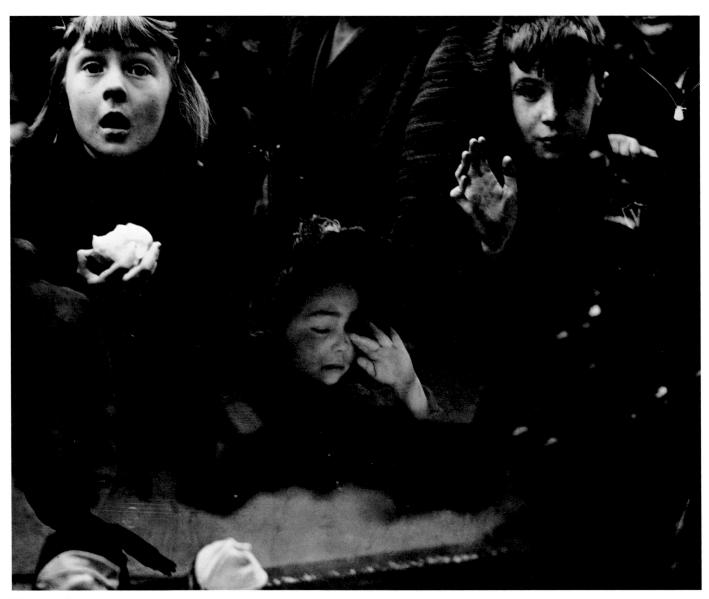

Watching Santa, 1944

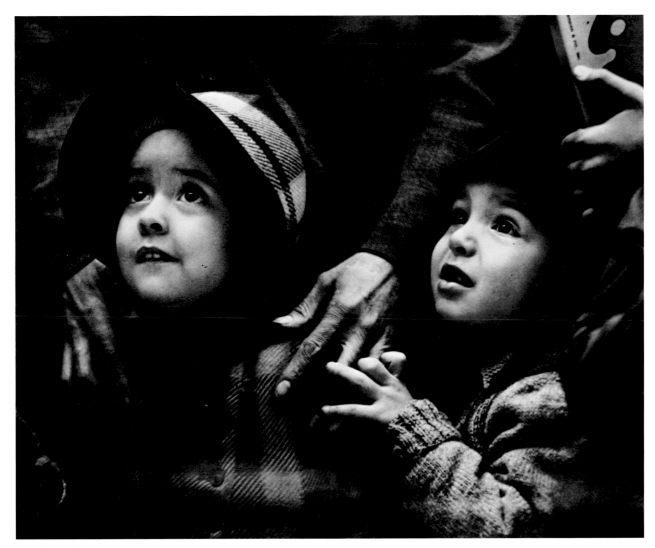

Watching Santa, 1944

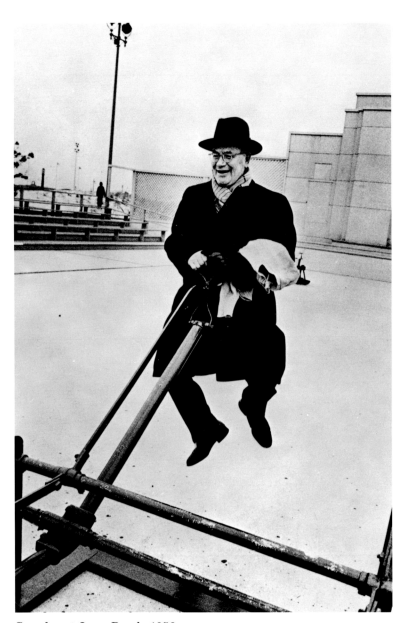

Grandpa at Jones Beach, 1956

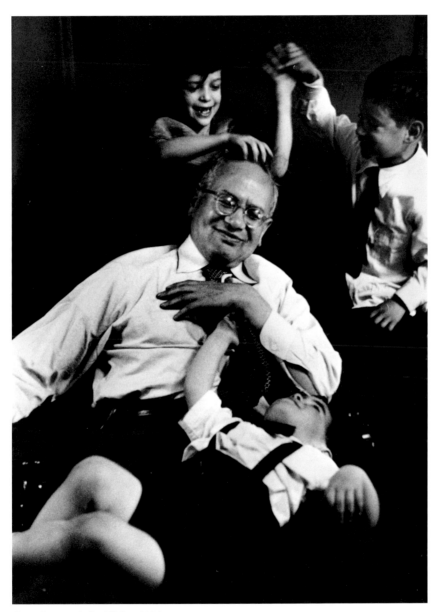

Grandpa and the Kids, 1953

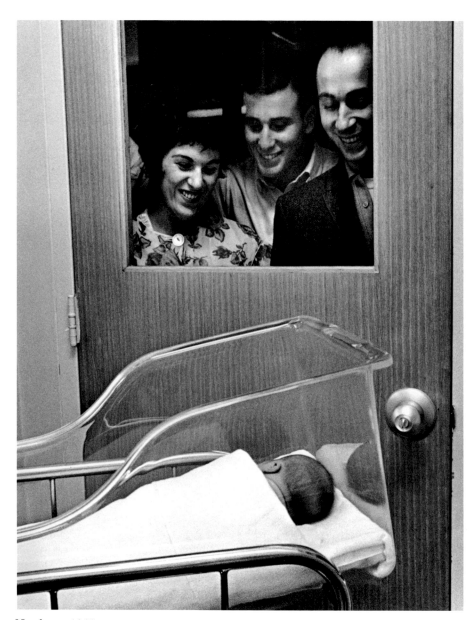

Newborn, 1962

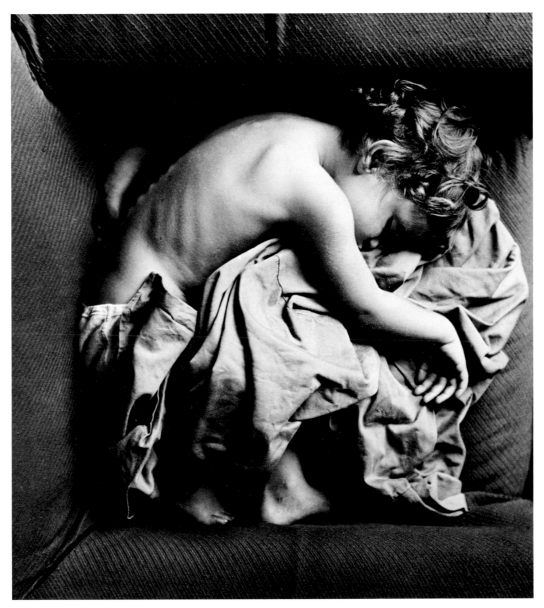

Sleeping Child, 1950

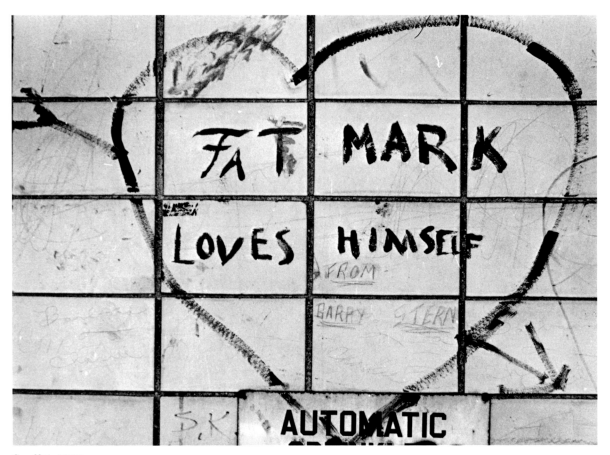

Graffiti, 1967

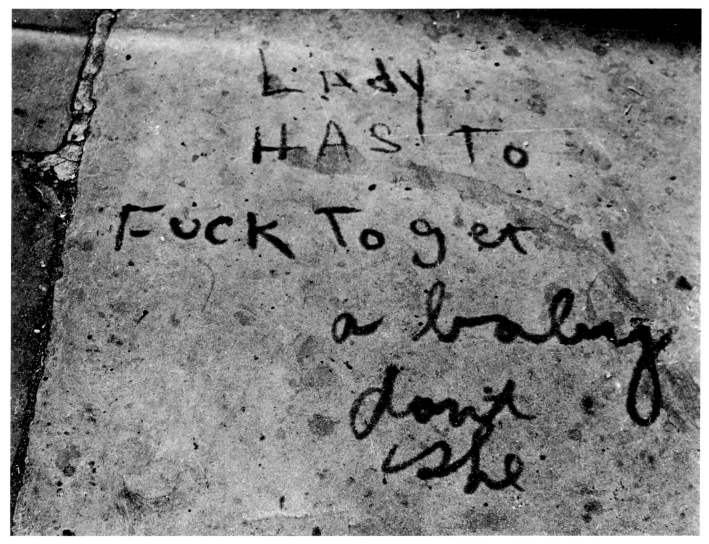

Graffiti, 1945

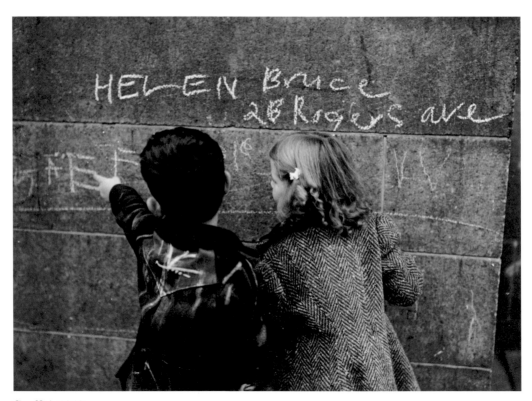

Graffiti, 1943

D.A.R.

I was working for *PM* in 1944, when I was sent to the Waldorf Astoria hotel to photograph a Red Cross booth. While I stood in the hallway, trying to figure out how to make a very routine picture just a little bit less dull, I heard something behind me. I turned and saw in the ballroom a group of women so fatuous they appeared to be caricatures: the room was overflowing with bejewelled, beribboned and tiaraed women posturing for the press. I had happened upon a convention of the Daughters of the American Revolution, and its members were truly astonishing. I forgot all about the Red Cross booth, and for the rest of the evening I photographed the D.A.R.

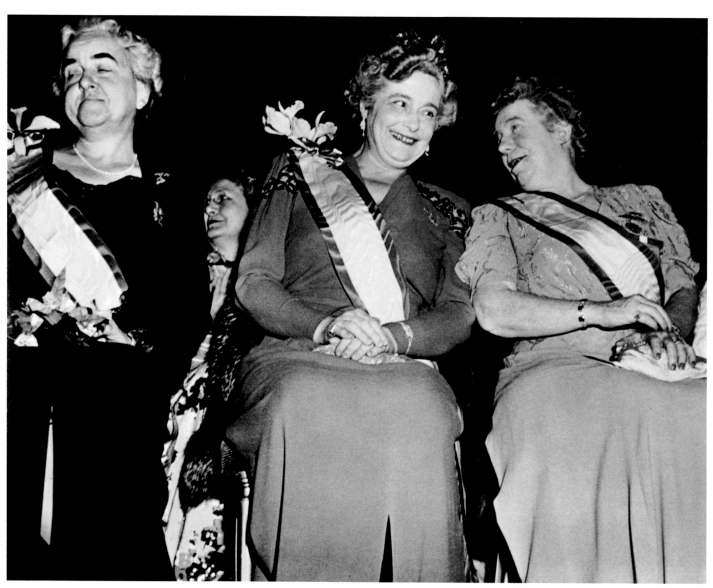

Daughters of the American Revolution, 1944

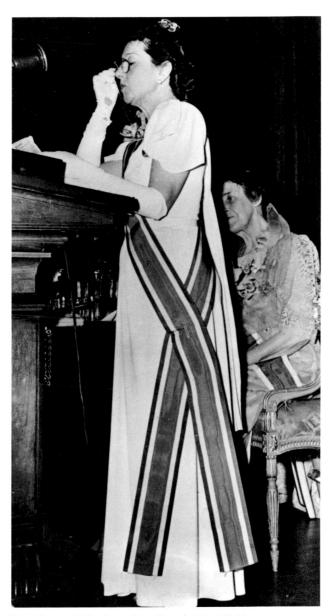

Daughters of the American Revolution, 1944

Opening Night at the Opera

Opening night at the Opera was a grand event, even though many of the people who attended were far more interested in the show they were putting on than the one they had come to see. They arrived in their limousines, dressed in all their finery, and entered through the side entrance, where the press was waiting. Reporters such as Earl Wilson interviewed them, and the photographers tried to "shoot" them for the society pages. A few of the "opera lovers" who felt they hadn't received enough attention actually walked out of the front door and returned to the side entrance to try again. Once inside, some did take their seats to see the opera but many just went to the saloon, laying claim to the best tables, never leaving them until just before the final curtain.

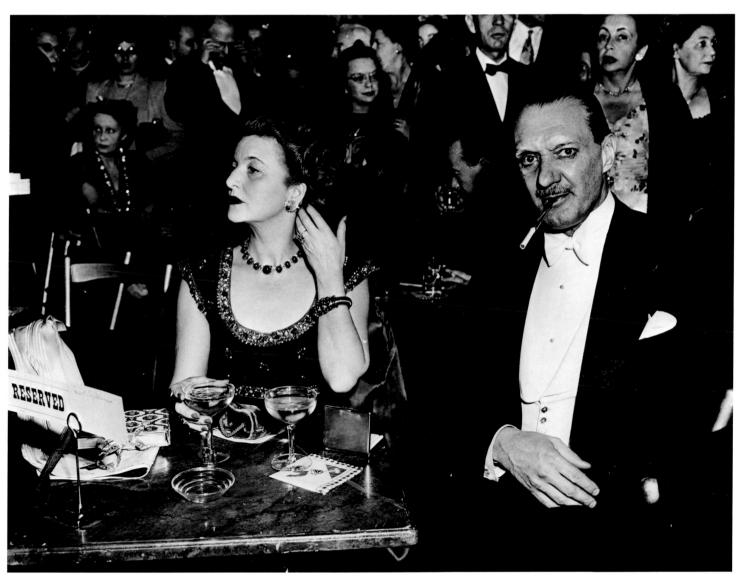

Opening Night at the Opera, 1946

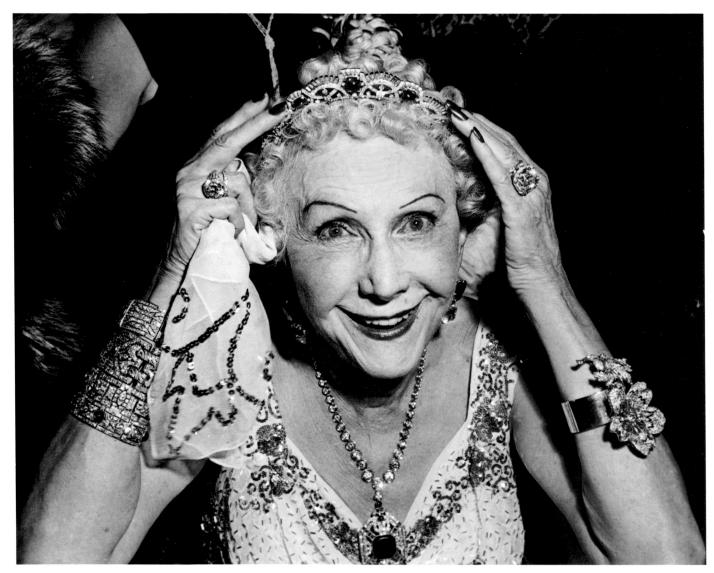

Opening Night at the Opera, 1946

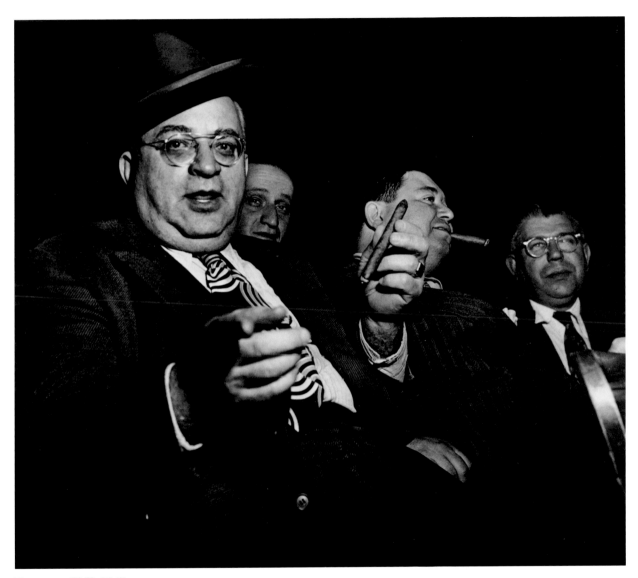

Tammany Hall, 1947

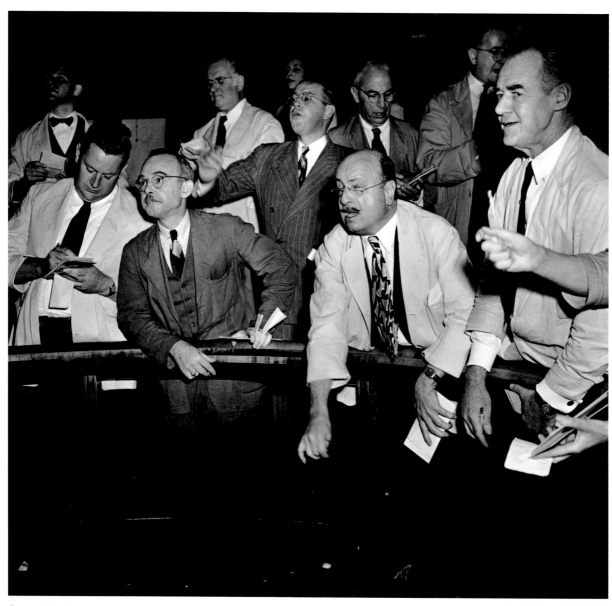

Cotton Exchange, 1948

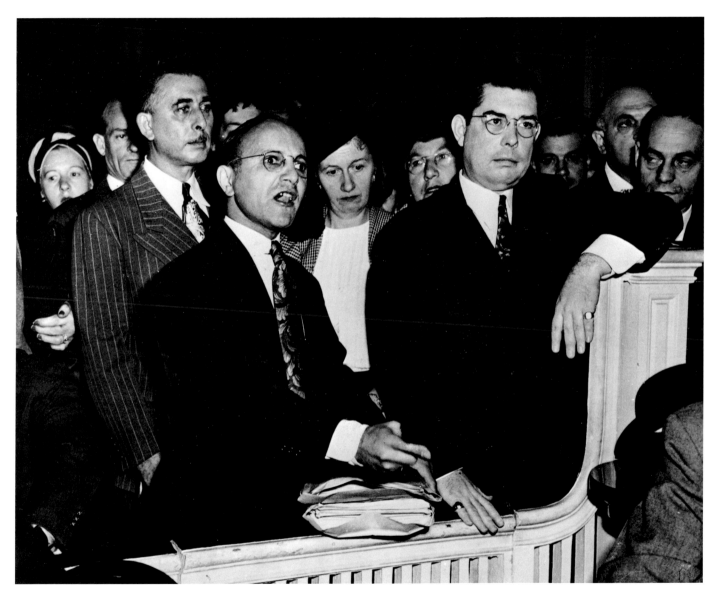

City Hall Petitioners, 1946

Mayor Fiorello La Guardia

Every Sunday morning Mayor La Guardia conducted a radio program from City Hall. One Sunday in 1944, I arrived just as the Mayor was beginning to go on the air. As I entered his office I was told that photographers were no longer allowed to shoot during the broadcast. With my pockets stuffed full of the large, explosive flash bulbs we used back then and my Speed Graphic open and ready, I took the only seat left: on a bench next to a general. The broadcast began, I shifted a bit in my seat and one of the flash bulbs fell out of my pocket and onto the floor, its explosion sounding like a powerful firecracker. The general jumped and La Guardia glared at me over his glasses. Another bulb immediately dropped to the floor and exploded. By this time, everyone in the room was staring at me, and I was sure that La Guardia thought that I was trying to sabotage his broadcast. I was mortified. I was sitting stiffly, afraid to move, when I realized that still another flashbulb was about to drop. I made a grab for it, but missed and the third explosion echoed through the room. Somehow I made it to the end of the broadcast, at which point I immediately went up and apologized to the Mayor.

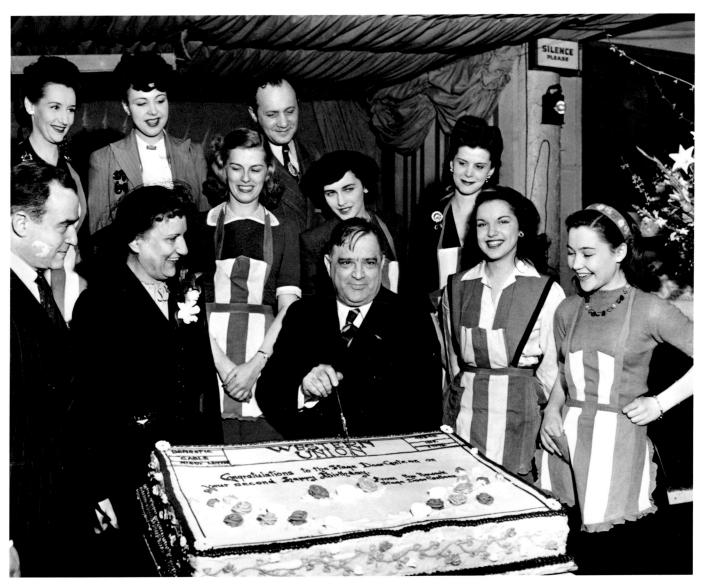

Mayor La Guardia at Stage Door Canteen, 1944

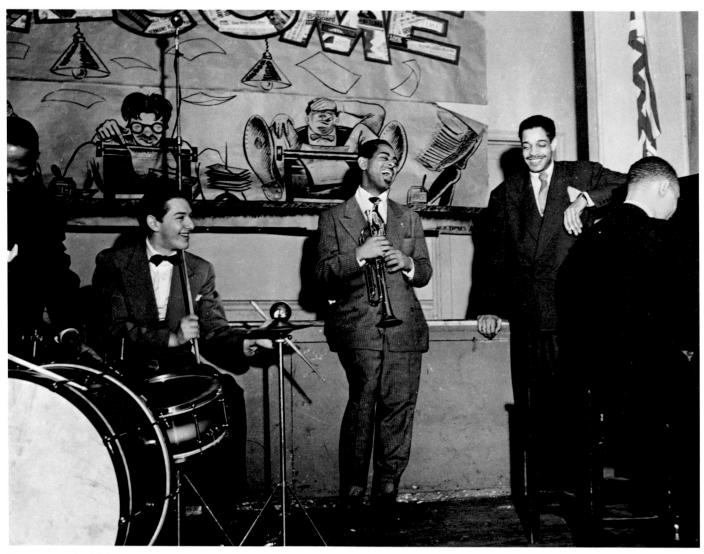

Newspaper Guild Canteen, 1944

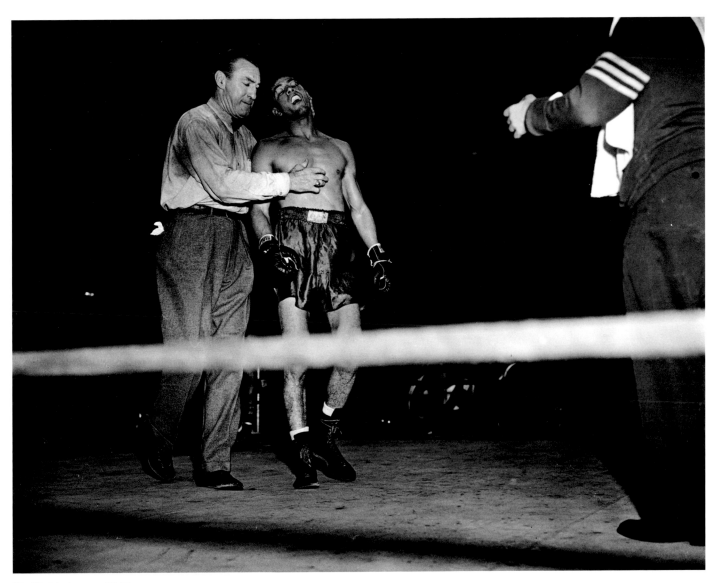

St. Nick's Arena, 1947

Louis Prima

I went to the roof of the Astor Hotel one very hot July night in 1945 to photograph
Louis Prima and his band. As I got off the elevator, the Maitre D' rushed over to me
and made it clear I was not properly dressed for the Astor Roof. I was wearing a short-
sleeved shirt open at the collar, no tie, and slacks. I gave him an amused look: I was
not there as a customer, I was on assignment. Still, I was turning to leave when half
the bandstand got into an uproar, Louis Prima among them. They surrounded me;
one lent me his jacket and one his tie, and I was persuaded to stay.

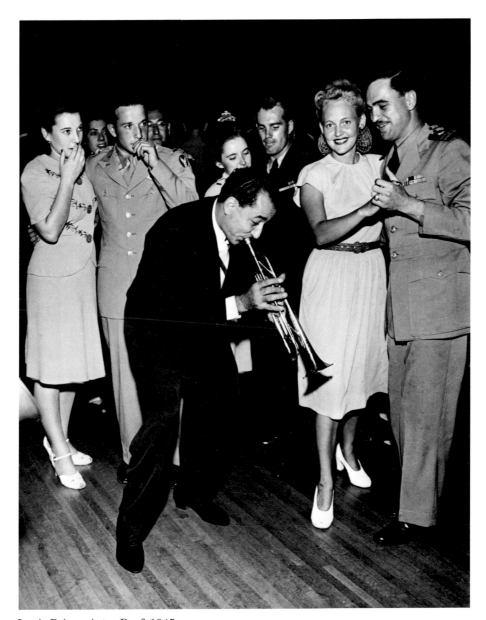

Louis Prima, Astor Roof, 1945

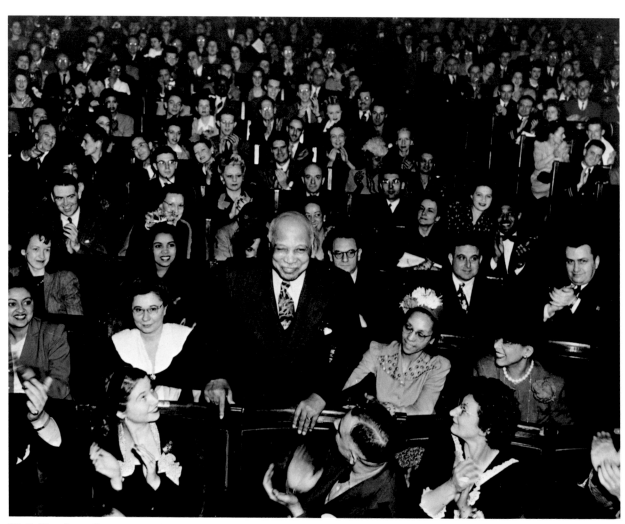

W. C. Handy at Carnegie Hall, 1946

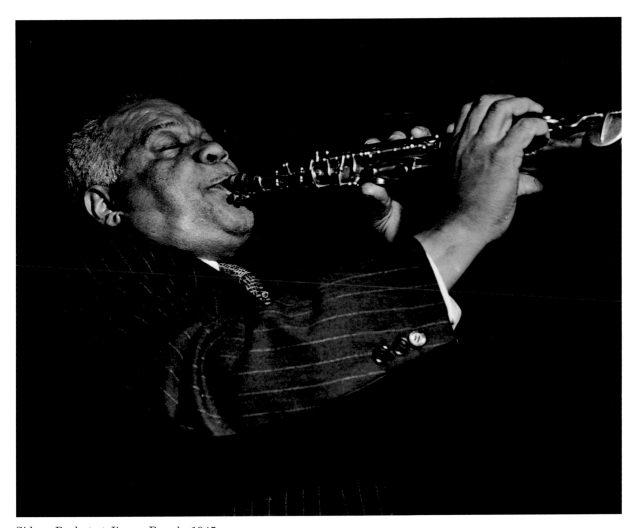

Sidney Bechet at Jimmy Ryan's, 1945

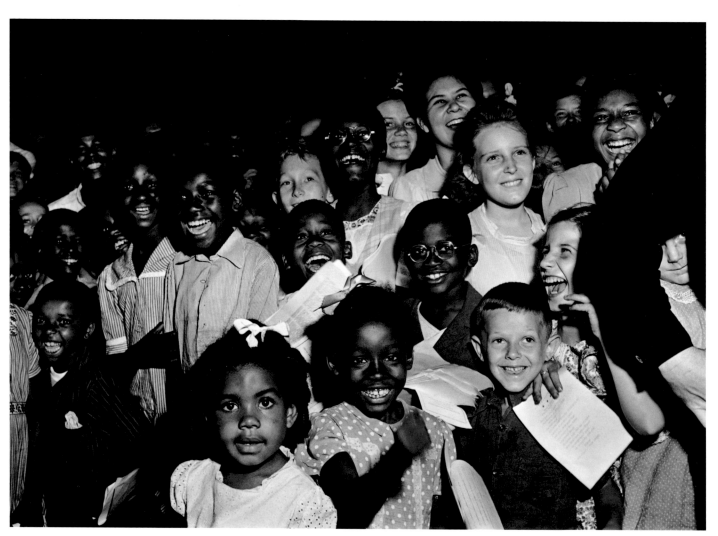

Unity Rally, World War II, 1945

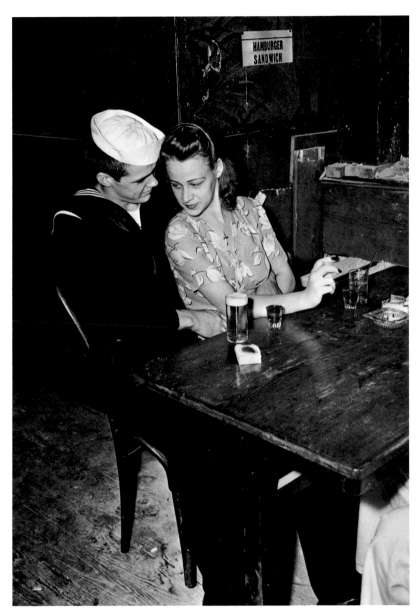

Sammy's Bowery Follies, 1945

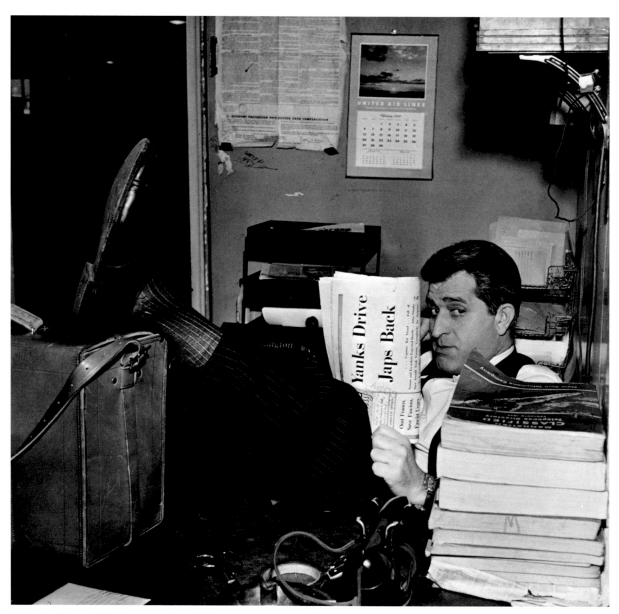

John De Biase, *PM* Photographer, 1944

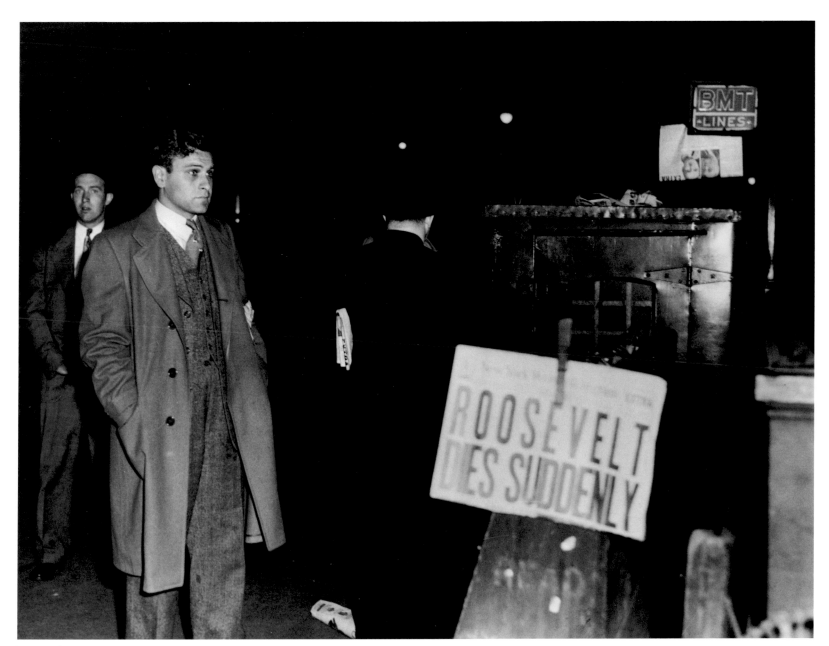

Roosevelt Dies, 1945

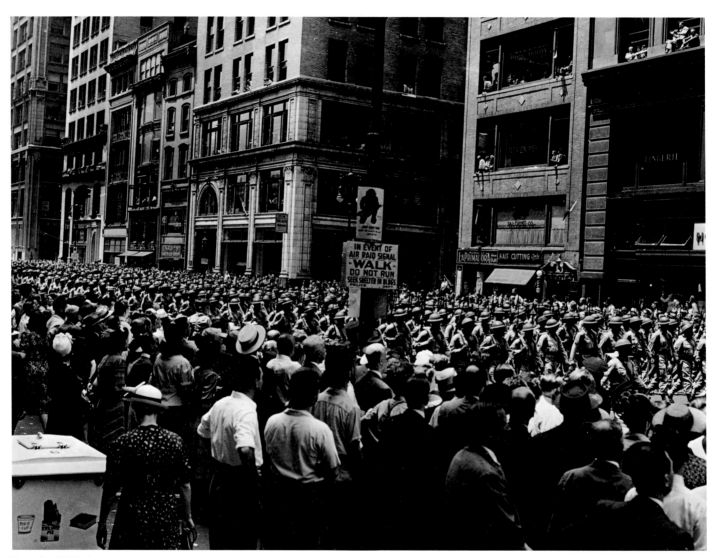

Parade, Fifth Avenue, 1944

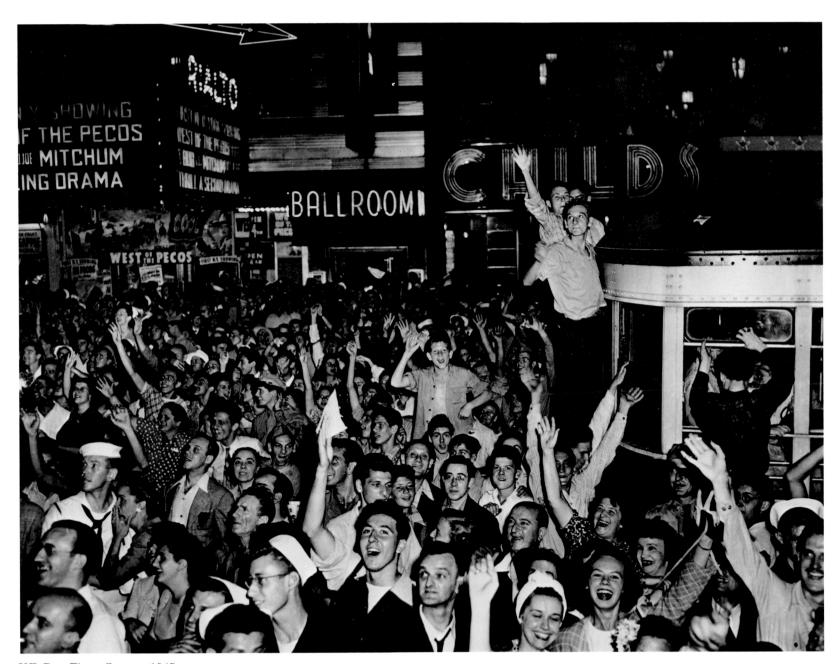

V.E. Day, Times Square, 1945

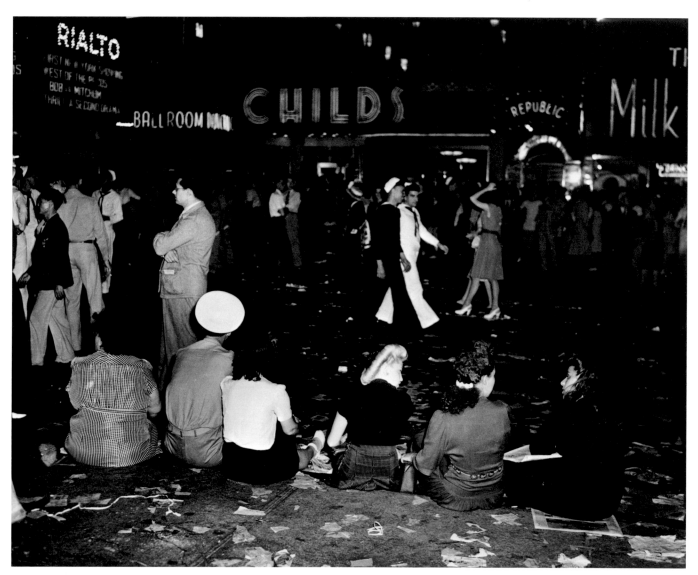

V.E. Day, Times Square, 1945

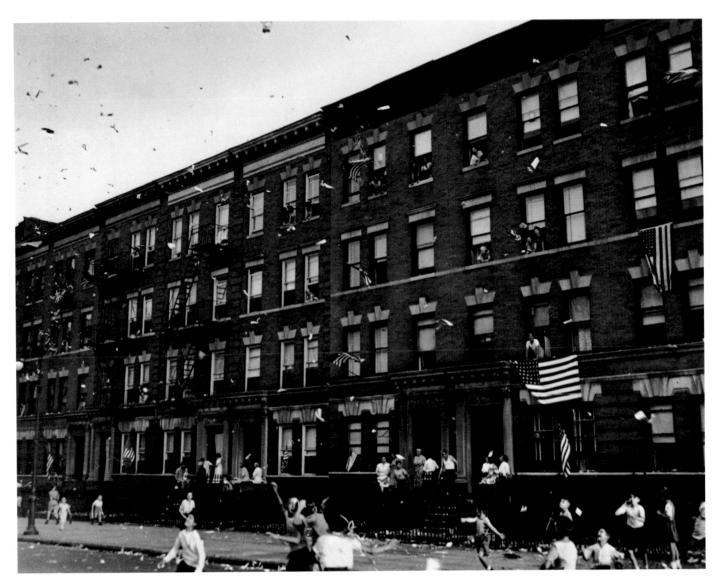

V. J. Day, Brooklyn, 1945

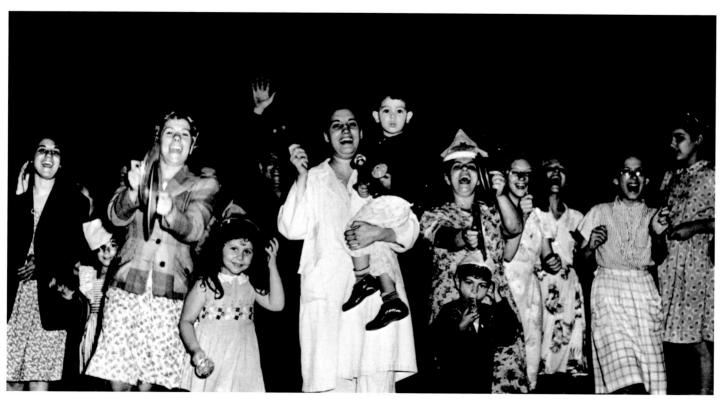

V. J. Day, Brooklyn, 1945

About the Photographer

Arthur Leipzig was born in Brooklyn, New York, in 1918. After studying photography at the Photo League in 1942, he became a staff photographer for *The Newspaper PM*, where he worked for the next four years. During this period, he completed his first photo essay, on children's street games. After a short stint at *International News Photos*, he became a freelance photojournalist, traveling on assignments around the world, contributing work to such periodicals as *The Sunday New York Times, This Week, Fortune, Look,* and *Parade*. Edward Steichen encouraged him to teach, which he did for twenty-eight years at Long Island University, where he is now Professor Emeritus.

Leipzig has been included in many museum group exhibitions, most notably "New Faces" (1946) and Edward Steichen's landmark "Family of Man" at the Museum of Modern Art in 1955, and the Metropolitan Museum of Art's "Photography as a Fine Art" in 1961 and 1962. His one-man exhibitions include "Jewish Life Around the World" at the Nassau County Museum of Fine Art, "Arthur Leipzig's People" at the Frumkin Adams Gallery, "Arthur Leipzig's New York" at Photofind Gallery, and retrospectives at The Hillwood Museum and The Nassau County Museum of Fine Art. His work is also represented in the permanent collections of The Museum of Modern Art, The Brooklyn Museum, The National Portrait Gallery, The Jewish Museum, and The Bibliothèque Nationale, among others.

Arthur Leipzig has received the National Urban League Photography Award, several annual Art Directors Awards, and two Long Island University Trustees Awards for Scholarly Achievement. He lives on Long Island.